ASPEN IN COLOR

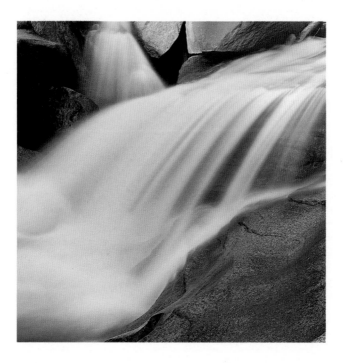

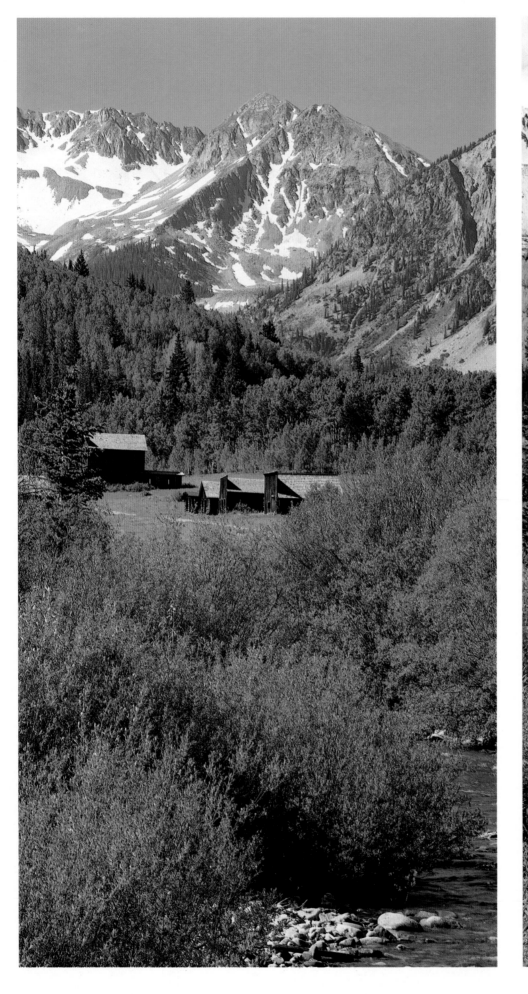
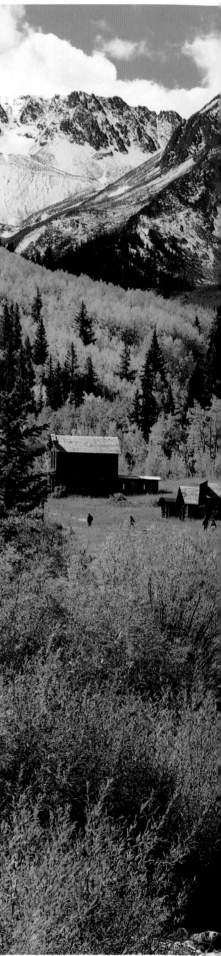

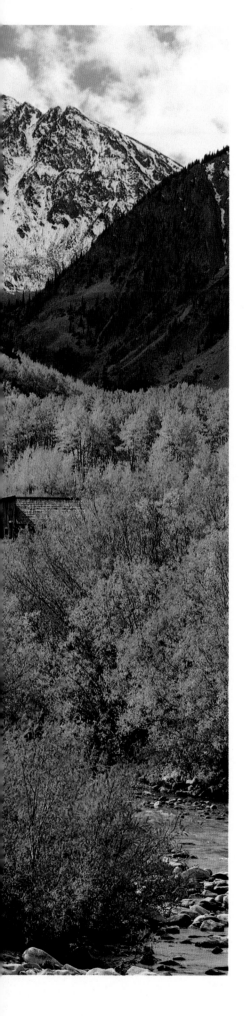
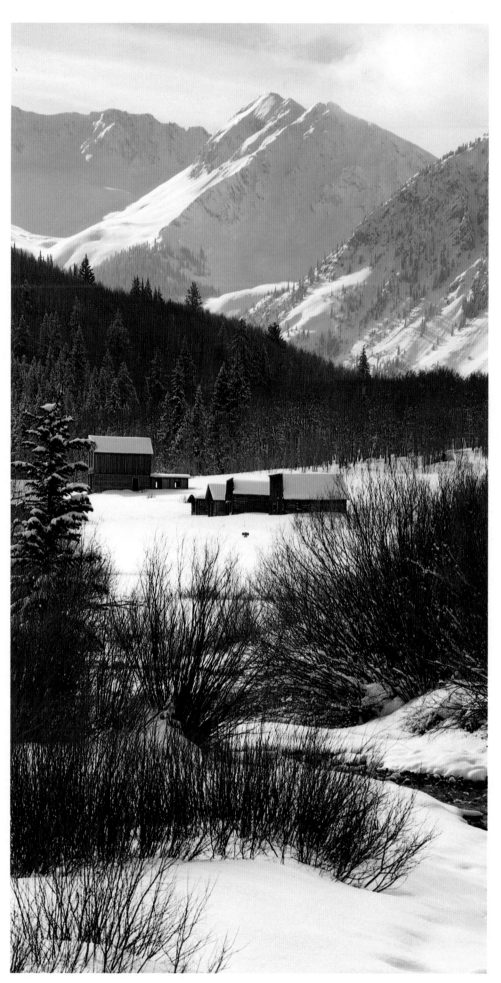

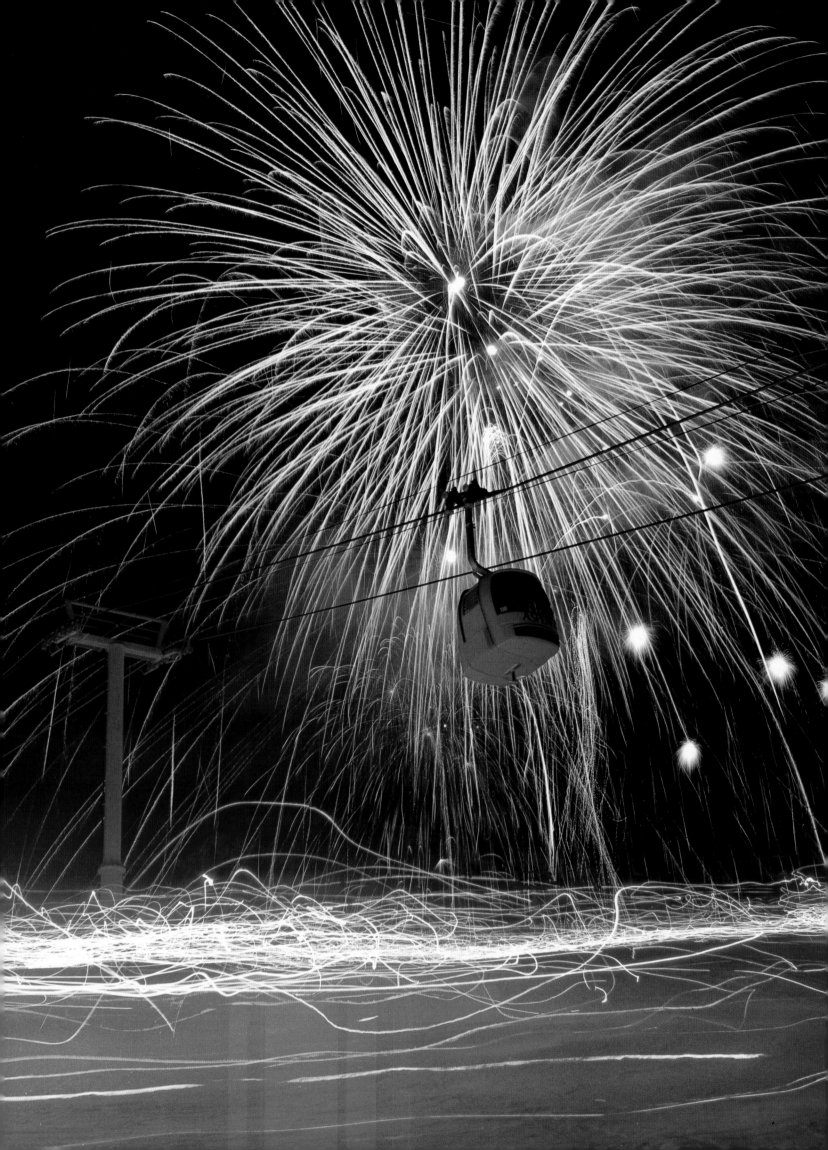

ASPEN

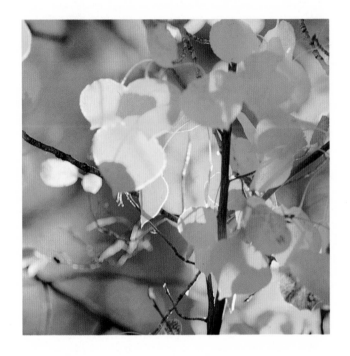

IN COLOR
Seasons of a Mountain Town

WHO PRESS

HALF-TITLE PAGE A veil of water spills over Grotto Falls
near the Independence Pass road where sculpted rock formations channel the
upper Roaring Fork River. Swimming holes abound and offer respite on hot
summer days, providing a haven for a high mountain picnic.

FIRST FRONTISPIECE Spring, autumn & winter give the ghost town of
Ashcroft a profound seasonal shift. A National Historic District, Ashcroft lies
at 9,500 feet, 11 miles up Castle Creek from Aspen. First a mining camp,
Ashcroft grew to a population of 2,000, only to lose its inhabitants to a more
prosperous Aspen. Today, visitors stroll through the townsite in summer or
don skis in winter and follow a network of quiet nordic trails.

SECOND FRONTISPIECE Aspen celebrates winter in a starburst of fireworks
with the six-man gondola in the foreground. A ski town since 1947, when the
first lift opened on Aspen Mountain, Aspen has long enjoyed winter as the
mainstay of its economy. Sports enthusiasts the world over value its powder
snow, precipitous slopes and colorful jubilees.

TITLE PAGE Gilt aspen leaves catch the light
of an autumn day in the high country.

Copyright © 1990 by Warren H. Ohlrich

PUBLISHED BY

WHO PRESS
Post Office Box 1920
Aspen, Colorado 81612

Library of Congress Catalog Card Number: 90-90323
ISBN 0-9620046-5-0

Edited by Warren H. Ohlrich
Text by Paul Andersen
Book Design by Curt Carpenter

Printed in Japan by
Dai Nippon Printing Company, Ltd., Tokyo, Japan

Typeset in Sabon and Post Antiqua by
Aspen Typesetting, Aspen, Colorado.

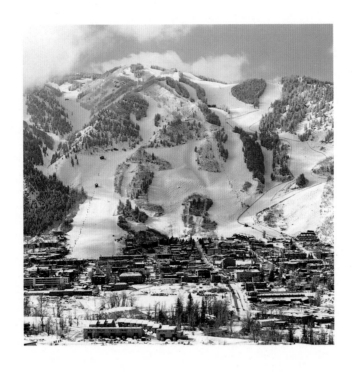

ASPEN MOUNTAIN, nicknamed "Ajax"
after a historic silver mine, creates a dramatic backdrop that
dwarfs Aspen. The town is laid out at its base much as it was
100 years ago when mining was in its heyday and ore was hauled
from town by two railroad lines. Still pockmarked with mine
shafts and swiss-cheesed by tunnels and drifts, Aspen Mountain
offers some of the most challenging ski terrain in the United
States. The famous World Cup course, called "America's
Downhill," is cordoned off on the right.

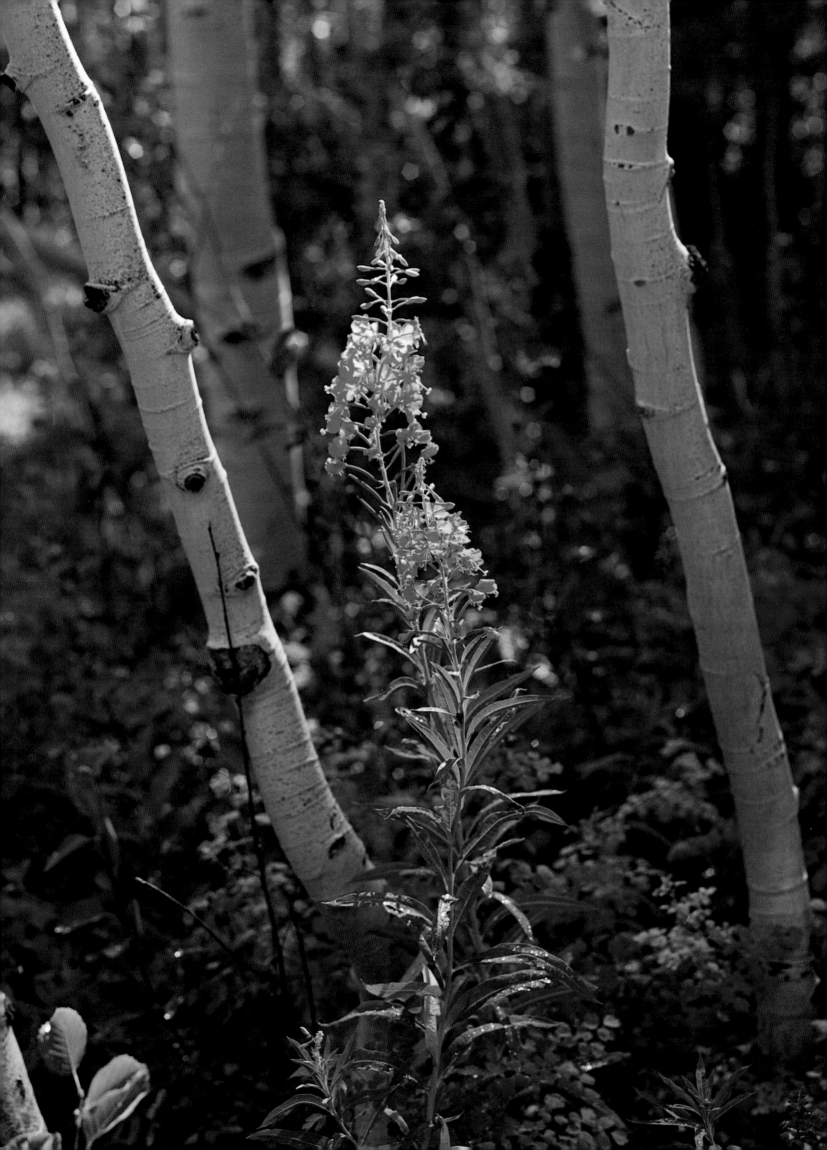

INTRODUCTION

For more than a century man and nature have struck a vague compromise in Aspen. From the time of the first Anglo settlements in the valley of the Roaring Fork in the 1880's, Aspen has considered nature as its primary resource. Whether mining town or resort mecca, nature's bounty has served both as a predominant allure and the subtle backdrop to a list of competing human activities. One of the essential elements of Walter Paepcke's "whole man" concept, and a cornerstone of the Aspen Institute for Humanistic Studies, which he founded, was a personal contact with the pristine natural world. For many, that remains Aspen's greatest gift and asset. It is what ASPEN IN COLOR is all about.

In its humble beginnings, Aspen was a camp city of tents and shacks huddled in a remote wilderness valley. A cornucopia abounding in fish and game, the valley had long been the chosen summer hunting grounds of the Ute Indians, who provided Aspen its first name: Ute City. But association with a tribe of Indians was not suitable for a cabal of hard-driven Eastern capitalists striving to establish a refined and cultured outpost, so Aspen was renamed for the trees which grew in abundance on the valley floor and up its mountain flanks.

Aspen's natural beauty was flaunted by boosters of the day who sang its praises in the broadsheet *Aspen Times*. But the obvious attraction was mineral wealth, and it brought hordes of miners who hoped to extract their fortunes in silver with dynamite, mule, pick and shovel. Aspen boomed with the riches of the earth, yielding strike after strike of high-grade ore. In keeping with the town's rising status the city fathers were driven to erect monuments to prosperity: a grand hotel, an opera house, two railroads to haul ore and commerce and to connect Aspen to the civilized East.

Aspen has followed a random evolution from frontier mining camp to modern international resort, a seat of culture and commercialism. Its genetic code was written by the people who

Fireweed catches a ray of sun where it grows in a forest of aspen trees. Known as one of the first plants to sprout after a fire or a disturbance of the ground, fireweed is prevalent in the Rockies and a sign of the healing powers of the earth.

saw a future here and contributed their often divergent influences. But the underlying theme is the town's true heritage, its flora, fauna, geology and climate. The single thread of continuity between all the peoples of Aspen, from the Utes onward, is the profound role of nature.

The geologic uplift of the Rocky Mountains, the river carvings, glacial excavations and seed distributions, the lengthy cyclic patterns that have fashioned the region into mountain peaks, verdant basins and narrow valleys, far exceed the schemes of man. Taken in context with its surroundings, Aspen is relatively insignificant. And yet it is a burgeoning urban experience that captivates most visitors today, overshadowing its very soul and essence. But travel five minutes into the mountains from any of the town's borders and the human world of order reverts to nature. Here is the undeniable pull of the natural world. For those whose sensitivities are inclined toward the land and its simple treasures, nature is able to reclaim the psyche just as a vine entwines an abandoned mill on a mountainside.

But the natural side of Aspen is least known today. Ours is a society looking inward. We are not the Utes hunting big game and fish and thanking the spirits for our bounty. Today we often seclude ourselves from the natural world, preferring the comforts of the indoors. We come to Aspen to ride chairlifts, to sit inside a tent for a concert, to sample restaurant fare or to shop at the stores. We most often view nature from behind the closed window of a car speeding along a mountain road.

The Elk Mountains, a range of 14,000-foot peaks surrounding Aspen, provide an escape from the harried world of man's design. Here among towering peaks and plunging streams, broad meadows and timberline basins is found a simplicity of purpose, a profound grace. Pursue nature in any direction from Aspen and the rewards are manifold. This is Aspen's real wealth, not in things material but in a random, free, thriving nature whose expansive realm buoys the spirit and underwrites the soul.

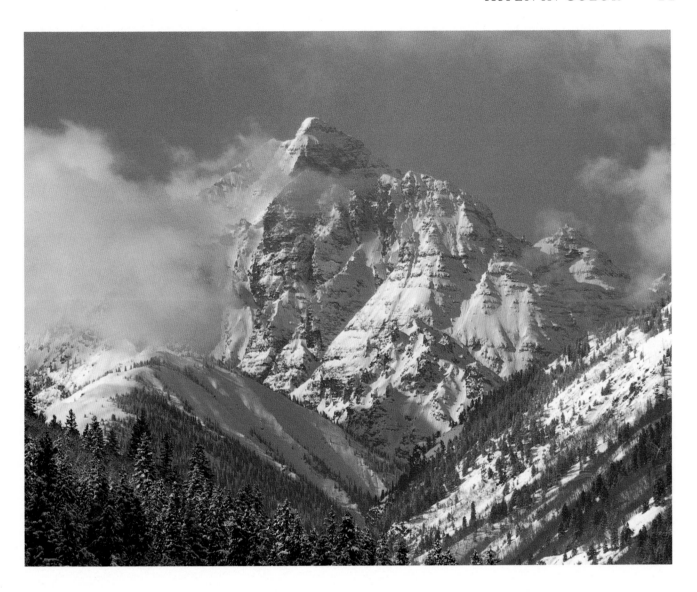

One of Aspen's landmark mountains, Pyramid Peak, at 14,018 feet, stands like a sentinel in the Maroon Creek Valley. Its allure has been fatal to a number of unwary climbers who have fallen from its rocky heights. The peak has been skied from its summit twice by daring local alpinists.

But for the naturalist, and there is part naturalist in all of us, Aspen is a rare blend where nature creates a living vitality, a peaceful mood, a lasting sense of belonging. Aspen offers a force of memory where pink fireweed flourish in the shelter of quaking aspen and the wind runs through their leaves with the sound of falling water. With a singular ease nature can open a door to a consciousness mostly foreign in the 20th century.

This collection of photographs offers an artist's perception of Aspen as a natural phenomenon. It is arranged by the seasons because they are what determine Aspen's changeable character. The human element is in the background, which is intentional. ASPEN IN COLOR offers a view of Aspen from mountain summits and hidden glens, from places where the air is fresh and the wind is cool, where the machinations of man are a secondary influence and always will be.

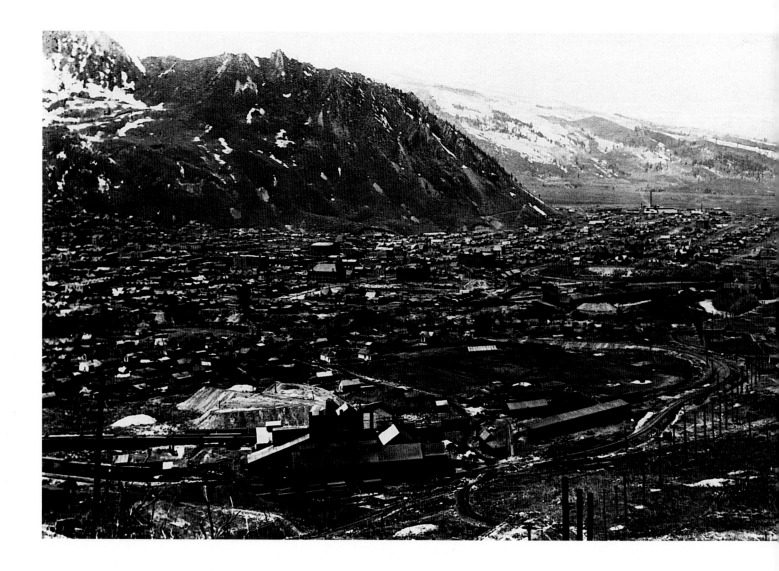

Aspen in the 1890's was a boom town boasting one of the richest silver deposits in the West. Mines like the Molly Gibson (foreground) pulled rich silver ore from the mountains. The ridgeline on the left, when viewed from a particular vantage point across the valley, outlines the famed "Silver Queen" in repose. Some of the historic buildings shown here include St. Mary's Church (1891), the Wheeler Opera House (1889), the Pitkin County Courthouse (1891) and the Hotel Jerome (1889), which still stand beautifully preserved today. The flurry of activity that built Aspen collapsed with the demonetization of silver in 1893, and the town gradually fell into a long slumber.

PERSPECTIVE

THE ASPEN TIMES • AUGUST 20, 1881

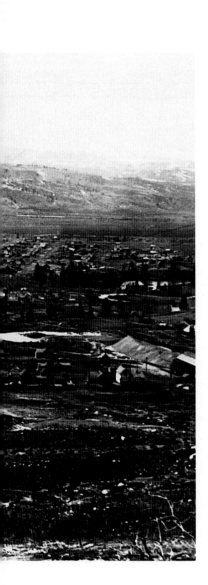

eautiful for situation is Aspen. No where on the broad
Pacific slope is there a site either among the mountains
or in all the valleys so lovely and charming as that of
Aspen, over the Range. Mount Aspen that stands guard
over the city; the Red Butte in the west; the range of mountains in
the south and the Elk Mountain to the east, whose gulches are
streaked with snow even in mid-summer, towering in the distance;
the great Ute spring in its quiet beauty pouring forth its crystal
flood; the Roaring Fork, dashing and foaming on its rocky way;
Hunter's Creek plunging along in its precipitous course, a constant
succession of waterfalls; Castle and Maroon creeks below, with the
wide expanse of valley in the west, combine features of beauty
rarely seen in conjunction. Romantic scenery is so common in
Colorado, that ordinarily the precipice or canyon attract no
attention unless marked by some extraordinary and distinctive
peculiarity, but we doubt, if any one of the human family, however
dull his faculties, however benumbed and weary with travel, or
greedy and avaricious for gain, ever entered this lovely valley
without feeling his spirits exhilarated by the cheerful and
animating prospect and giving voice to the exclamation "how
beautiful!"

Aspen is not simply a stopping place, a way station
where the pilgrim stops for temporary refreshment or repose,
where a man camps until he has made his pile, and then abandons
the scene for fresh fields and pastures new, but is has all the
essential elements of home, a place eminently fit to erect a temple
for our household gods—here to worship, here to live and to
cherish our friends, and when the inevitable doom approaches,
here to die and be buried with these everlasting hills to keep watch
and ward over our sepulchre.

These facts, which cannot be denied, invest Aspen with
advantages not usually possessed by the western town. It tends to
make our population more permanent. Aspen will not possess that
evanescent and changeable character which has come to

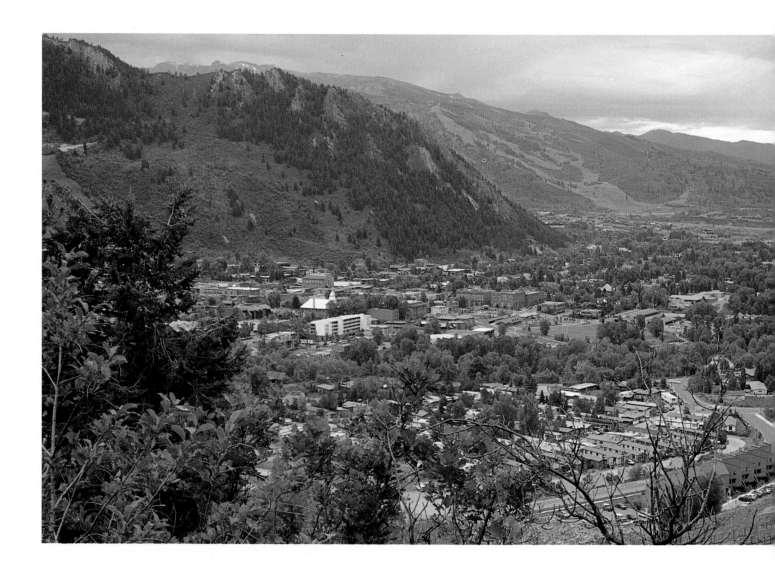

The Aspen of today recounts the glory of the mining days. Many of the old buildings exist, but the mining remnants are mostly gone. Today's wealth comes from a thriving tourist industry, both summer and winter, and the town has become a world-class resort mecca. Nonetheless, a working mine on Aspen Mountain maintains a glimmer of the past and the riches of the silver boom days lay beneath the surface of the "Silver Queen," whose repose is an expression of Aspen's dormant mineral wealth and grubstaking history.

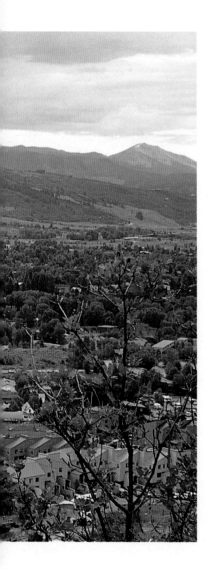

distinguish the frontier town; to-day, its canvas tented streets busy with all the bustling trade and dissipations of a large city, and to-morrow silent as the streets of a deserted village, whose citizens have, like the wandering Arabs, struck their tents and stole away. The tendency will be to make permanent improvements, to build school houses and churches and found societies whose influence for good shall increase with their years.

The pure air of the mountains, our altitude which places us above miasma and yet has located us far below timber line, the natural facility we have at small expense to water our streets from the never failing streams that ceaselessly pour by their floods in such profusion—the ability each citizen has to overshadow his hearthstone with the trees of the forest, or to fill his garden with vegetables and flowers, are all advantages the importance of which as yet we have no adequate conception. Salt Lake City has developed these same advantages to a great extent, and has made that city a point for the tourist second to almost none in the Union.

Independent of the rich ores that vein our mountains and which are to fill all our gulches with shafts and tunnels, make every hilltop resound with the blows of the pick and blasts of mining, and fill this whole region with a hardy and industrious class who shall vex the bowels of the earth for silver, Aspen has qualities which added to these advantages cannot fail to make her both populous and prosperous. Let us realize the situation and lay the foundations of her prosperity broad and deep, that we may enter and enjoy the full fruition of this fair land.

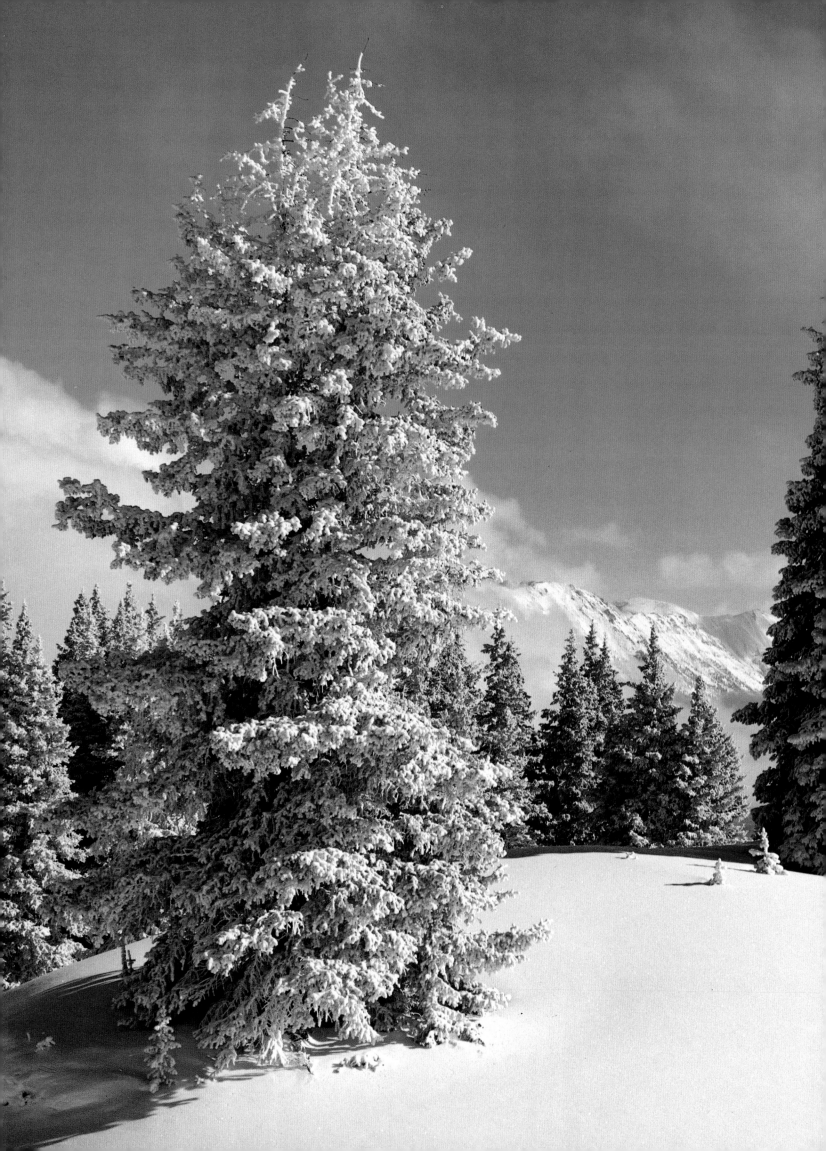

WINTER

A mantle of snow sugarcoats spruce trees on Little Annie Basin on the backside of Aspen Mountain and smooths over the rolling contours through the glades leading down into Difficult Creek. Not far from lift-served terrain, Little Annie remains a playground for cross-country skiers, snowmobilers and patrons of a snowcat powder skiing program operated by the Aspen Skiing Company.

It never comes fast enough for skiers who want deep, dry snow for the lift openings in November. Winter is cagey. It dabbles, first with a short, hard snow, then a biting wind, a thin frozen crust on a pond. The first cold snap makes a hot, crackling stove the center of attention. And when it finally settles in, winter hurls itself into the valleys and the mountains with a savage fury. The snows come. Each storm carries its burden of white and lays it out even and easy over the landscape. The air is harsh and reddens the face and hands. Winter means shovels, snow tires, powder skiing, Winternational and America's Downhill. It brings the roar of snow guns to the mountain, the growling snowcats grooming a run, excited après-ski chatter over hot drinks. It is the season for which Aspen is best known, when skiers make their pilgrimages from the world over. Aspen becomes a commercial hub of activity. But in the backcountry winter is a stark and quiet time, a world of snow and cold when nature is an awesome force. There is peace in the frozen world.

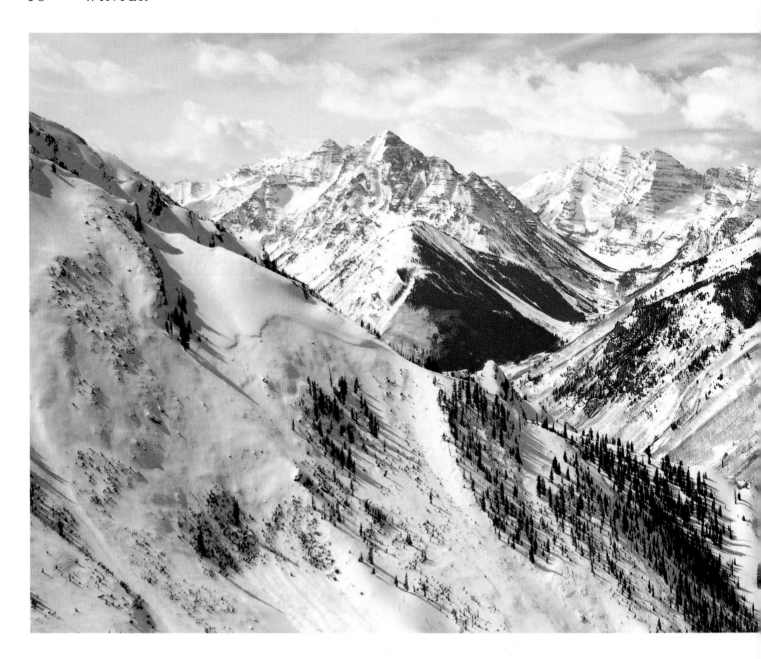

The dramatic Elk Mountains border Aspen to the south and west. This view from Aspen Highlands shows Pyramid Peak (left) and the Maroon Bells with the ridge connecting to Mt. Baldy (right) and the Snowmass Ski Area. Mostly consigned to an official Wilderness designation, these mountains represent Aspen's greatest natural asset, a wealth of majesty and wild beauty.

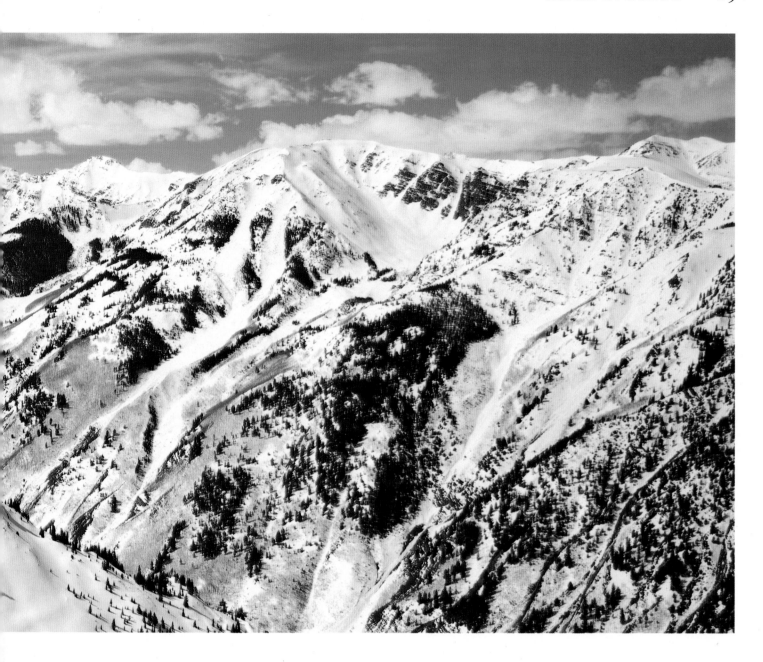

OVERLEAF From above, the grid of Aspen's streets appears miniscule given the vast range of mountains closing it off from the rest of the world. Impenetrable during winter except for experienced mountaineers, these mountains ensure that the town remains on a frontier with pristine nature. Ski runs on Aspen Mountain, cut decades ago, are among the most popular in America.

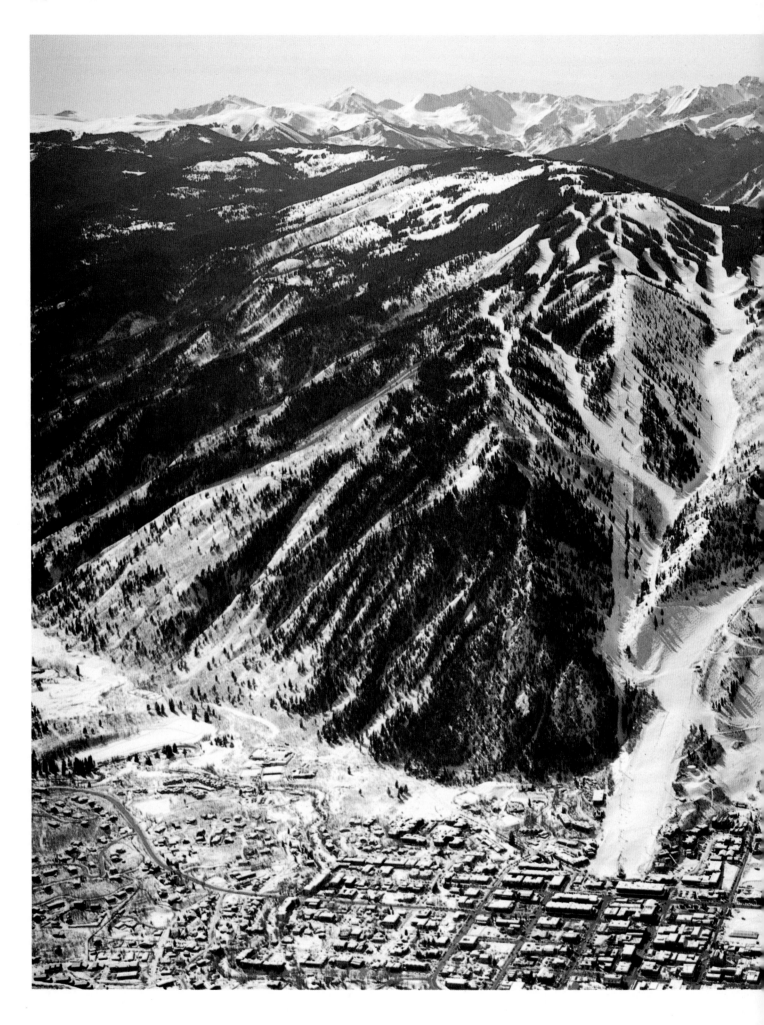

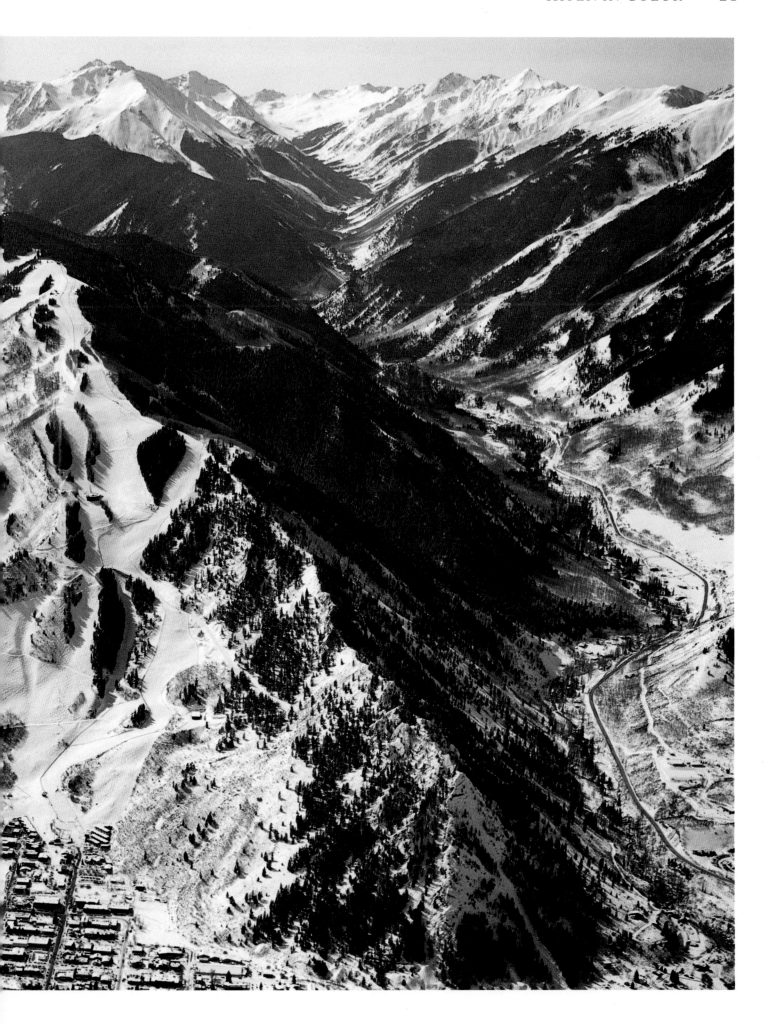

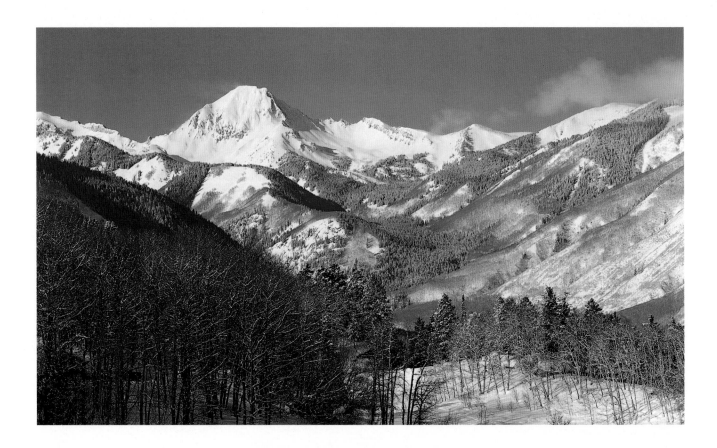

Mt. Daly, at 13,300 feet, rises above Snowmass Creek with its precipitous east face and open, sun-filled basin. Shown here in the early morning light, Daly is one of the prominent summits in the Elk Mountain Range. The cabins in the foreground are part of the Krabloonik kennels where dog sled teams begin trips into the designated Wilderness of East Snowmass and Snowmass creeks.

RIGHT Aspen and conifers mix in the undulating terrain of Campground, part of the extensive Snowmass Ski Area. Here a gladed snowscape offers excellent ski terrain and quiet mountain beauty. This transitional forest supports a wide variety of flora, making way for the gradual incursion of conifers.

OVERLEAF Streaked with sun and textured by skiers, the face of Bell Mountain is pocked with moguls and stubbled with spruce and fir. A favorite face for expert skiers, Bell is renowned for good fall lines and challenging terrain. It is an outstanding feature of Aspen Mountain and a visual feast in the afternoon light.

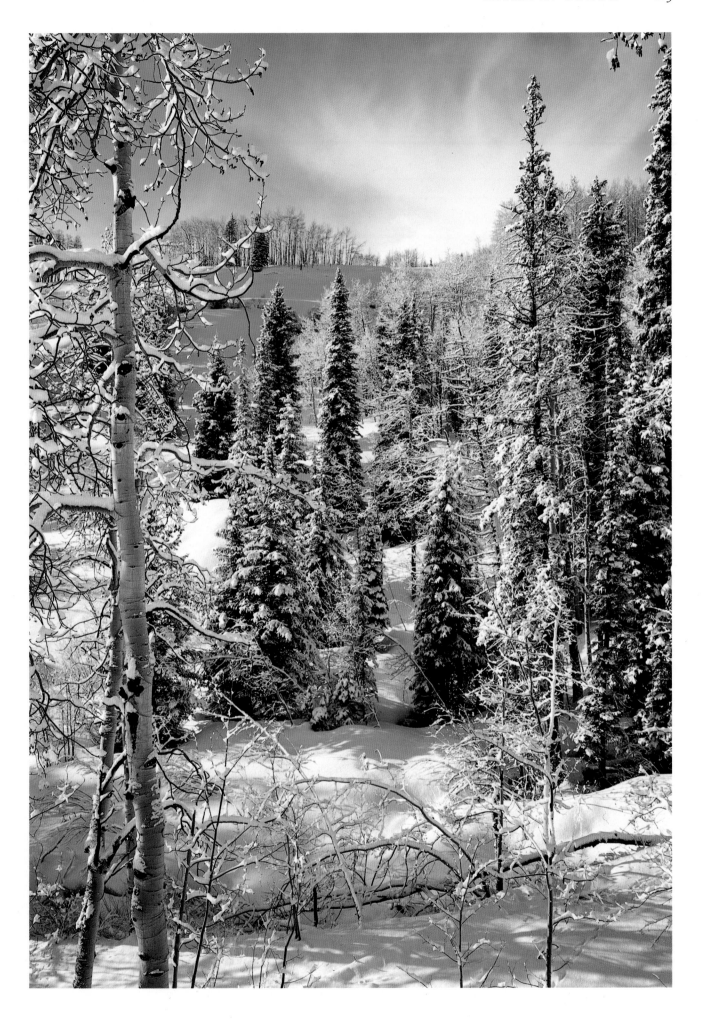

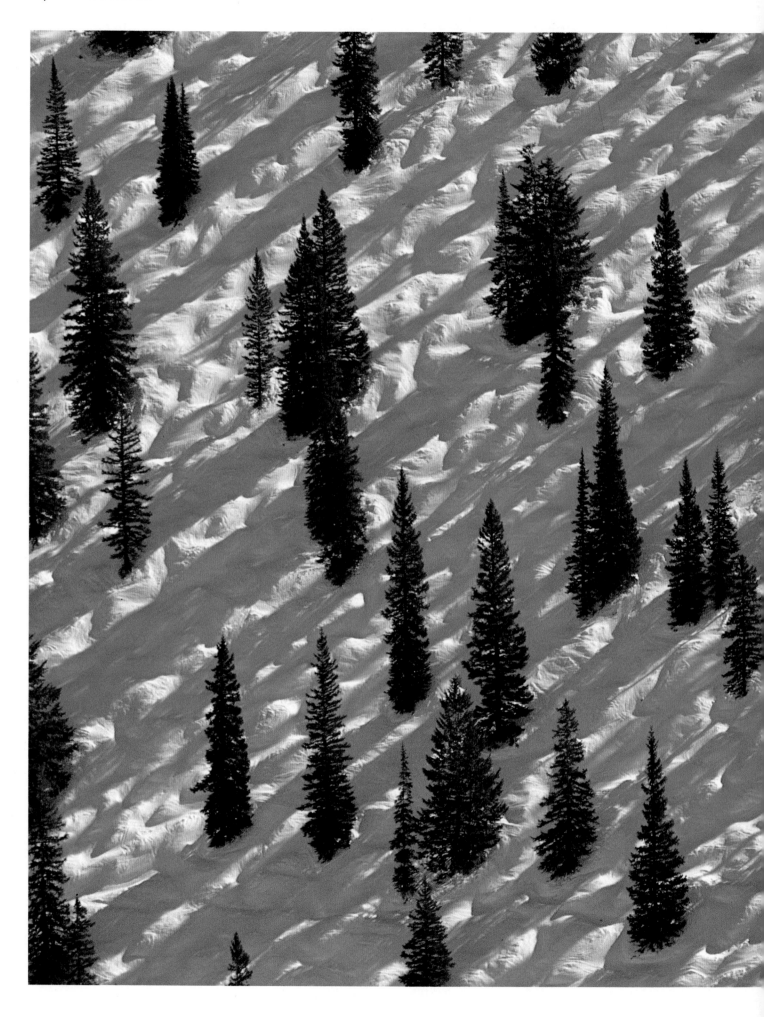

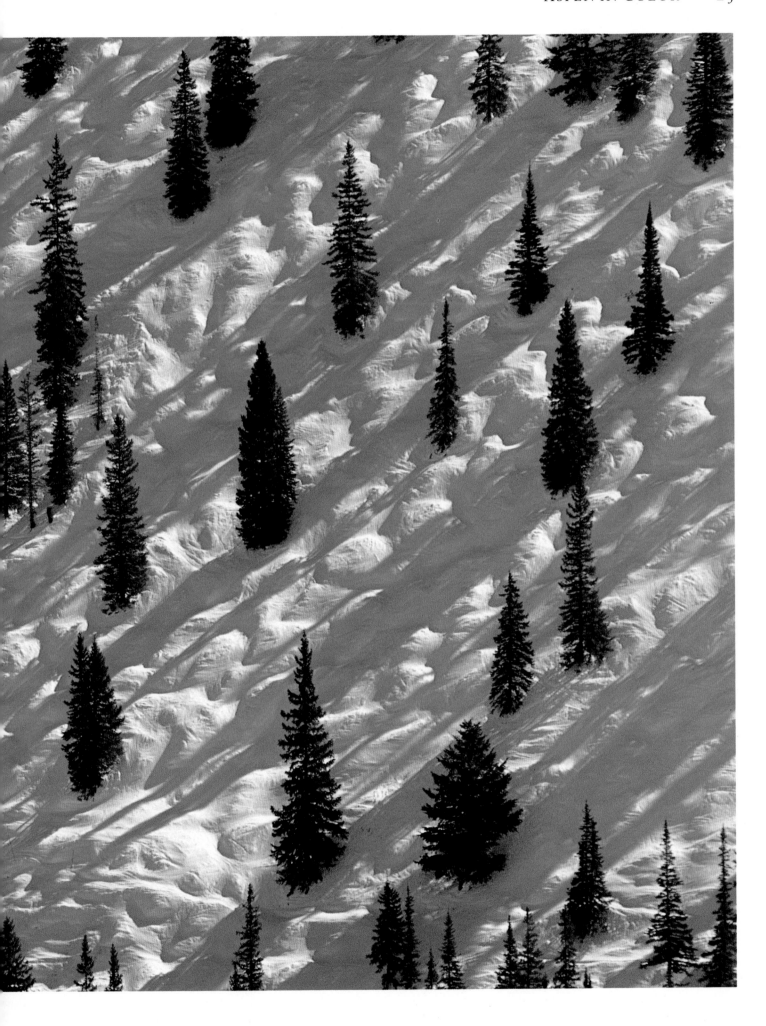

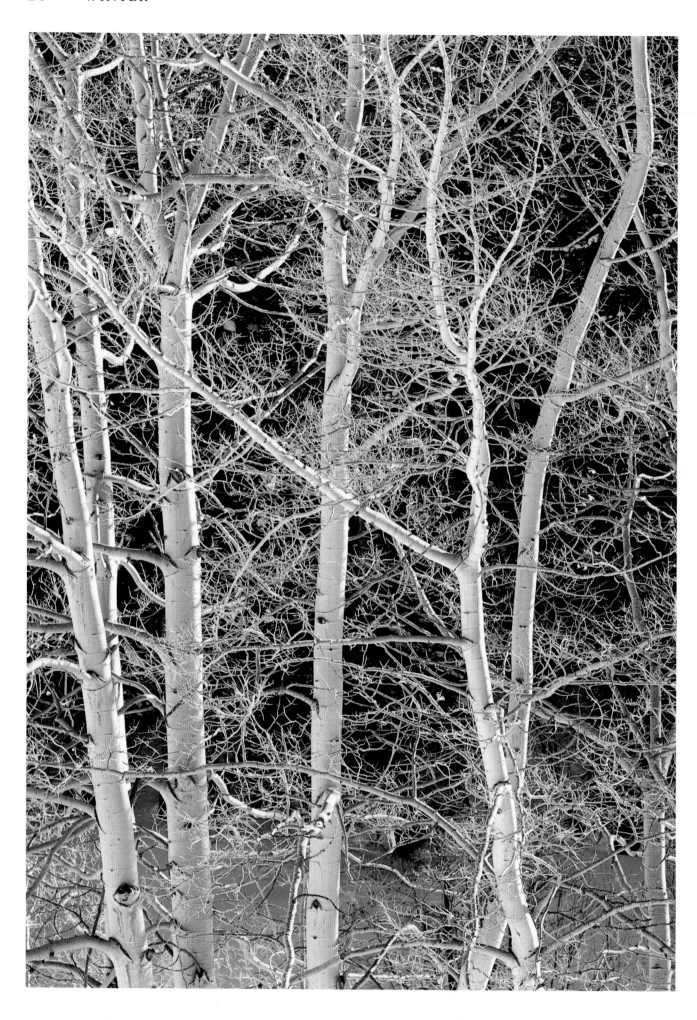

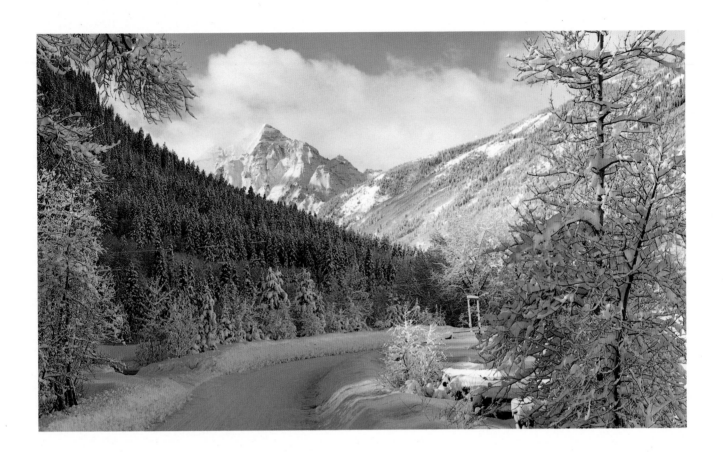

LEFT The cream-colored trunks of aspen trees stand out against a dark conifer forest illustrating the stark transition from aspen to evergreen. Such contrasts are a hallmark of the Colorado high country and create an abstract and web-like pattern on a winter day.

ABOVE Maroon Creek Road is a popular gateway to the mountains, climbing into the mountainous valley between frosty snowbanks toward Pyramid Peak. The road follows Maroon Creek as it winds through a dense forest of spruce and fir. Winter clouds billow around Pyramid and the chill of winter is in the clear, thin air.

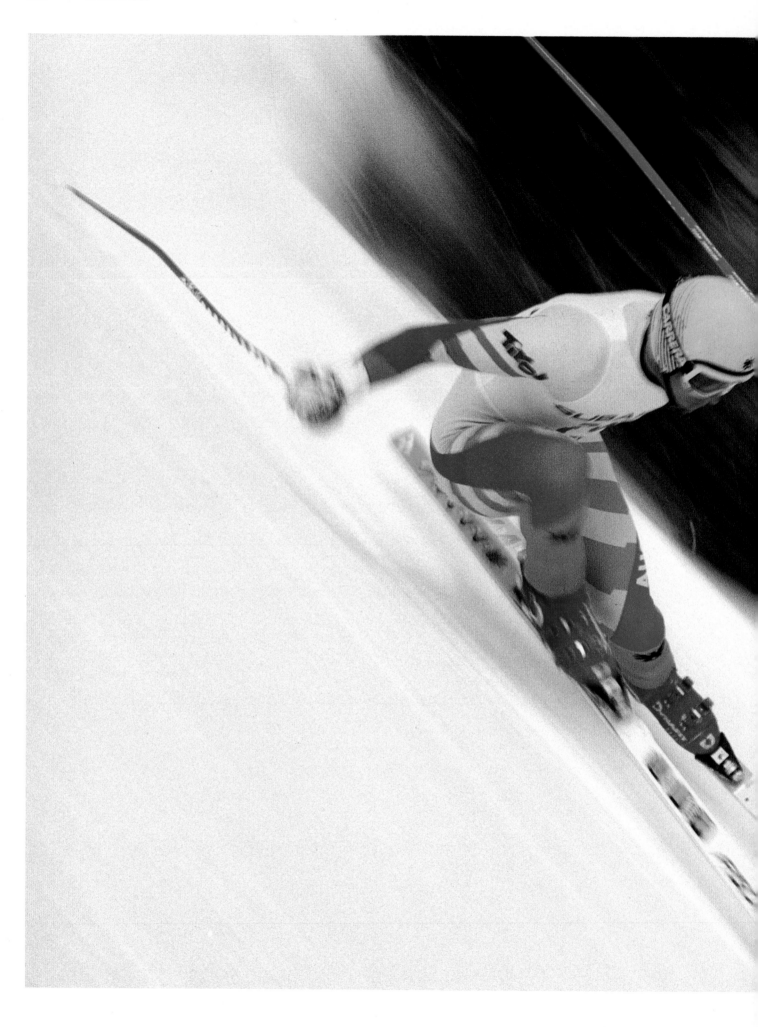

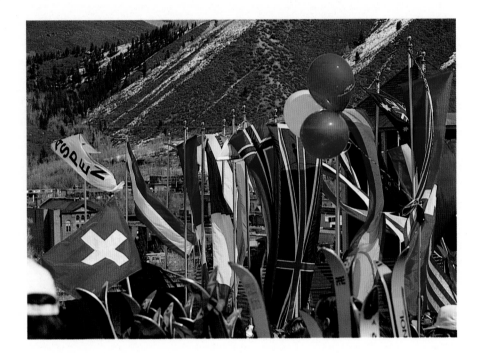

Aspen's international flair is highlighted by World Cup ski racing, an event that brings the world's top skiers to Aspen Mountain for three days of intense and grueling competition. The World Cup downhill, held on "America's Downhill," challenges technique and strength as skiers reach speeds in excess of 70 miles per hour. Flags representing many nationalities decorate the town and foreign languages are bantered about casually in dozens of restaurants. Aspen retains a long-standing tradition as a prime locale for world-class ski racing.

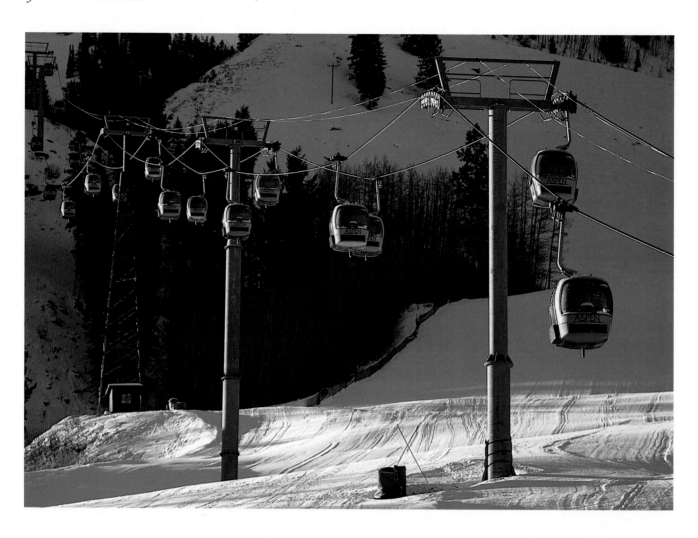

Aspen Mountain, once home to many a rich silver lode, is now serviced by state-of-the-art lifts and groomed to perfection. Skiing has put Aspen on the map since 1947 when the mountain boasted a one-person chairlift. Today, a six-man gondola on Aspen Mountain whisks skiers the 3,267 vertical feet from the base to the top of the mountain and at the time of its construction in 1986 provided the most vertical of any gondola in the world. The trip takes roughly 15 minutes. From the top the options are endless. The terrain ranges from intermediate to experts only.

OVERLEAF Fireworks and a torchlight parade brighten Aspen during Winternational, first held in 1981 to celebrate one of America's premier ski races. This pyrotechnic display is a lasting memory for anyone who has seen it and marks Aspen's enthusiasm for World Cup ski racing. The spectacle inspires awe as the fireworks are some of the best in the world.

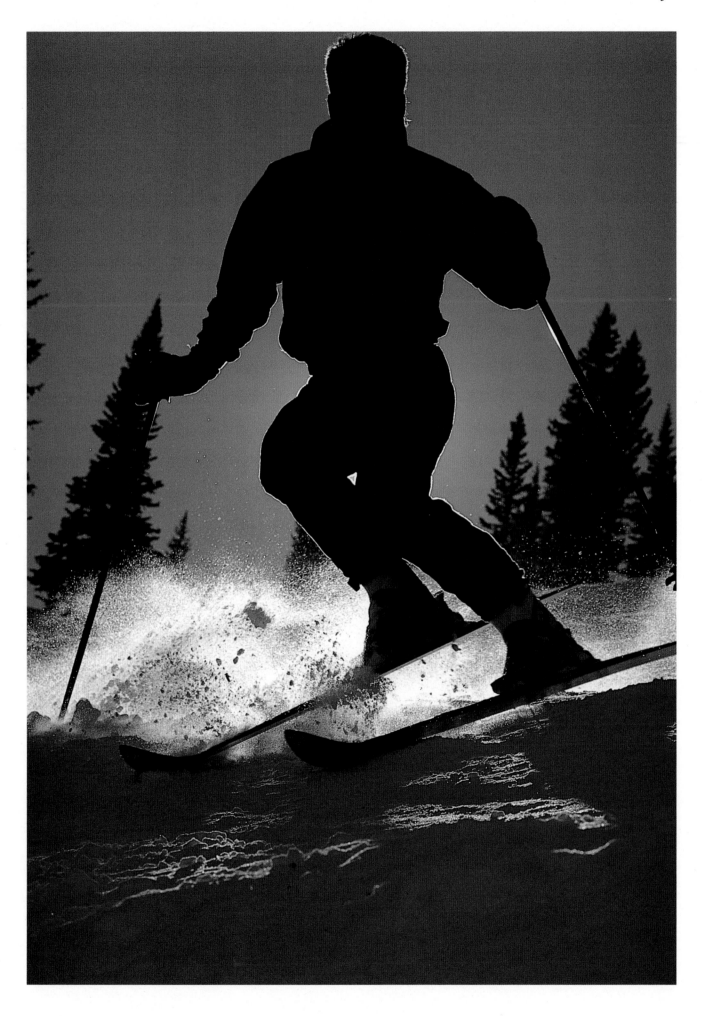

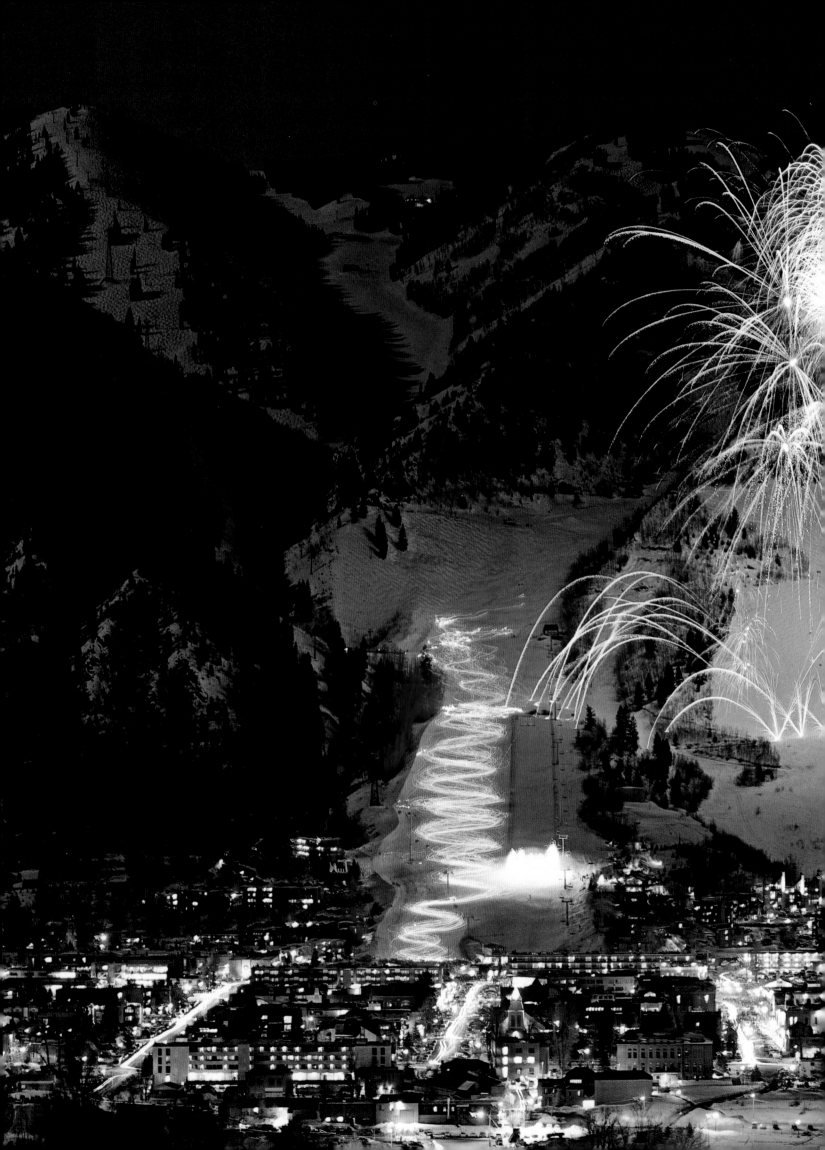

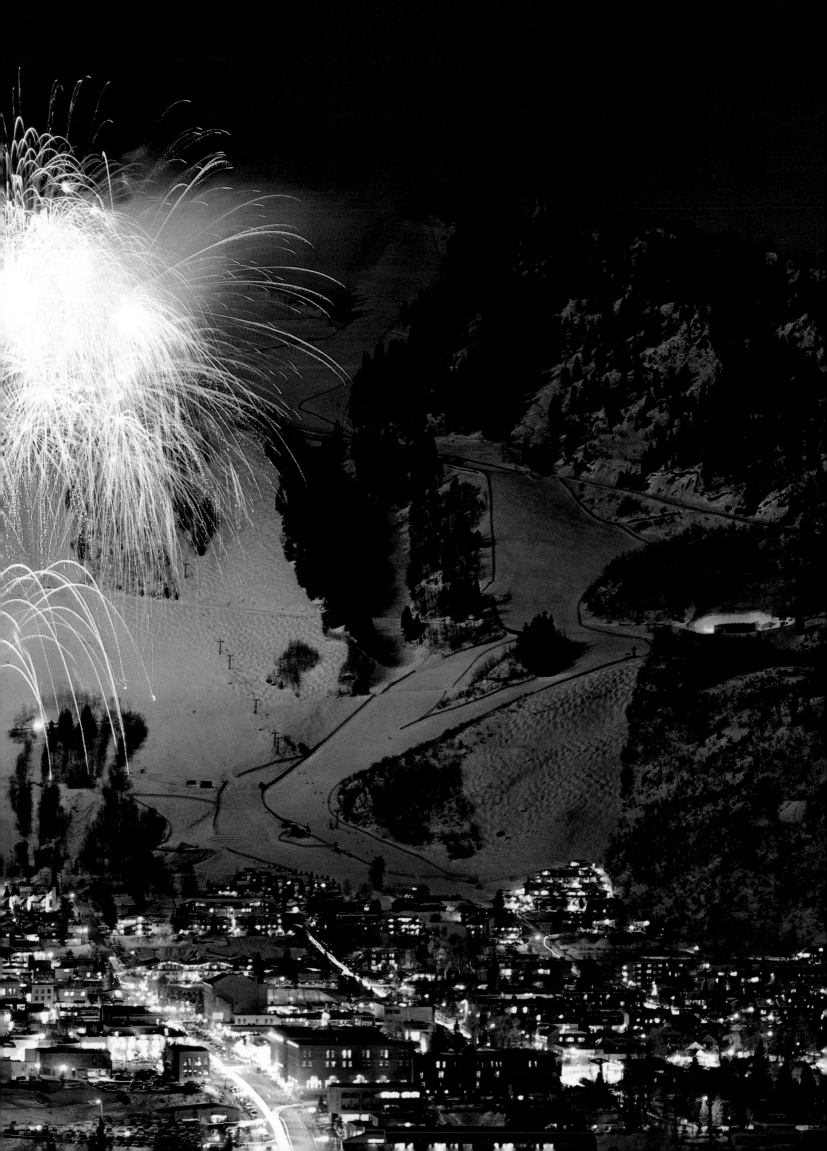

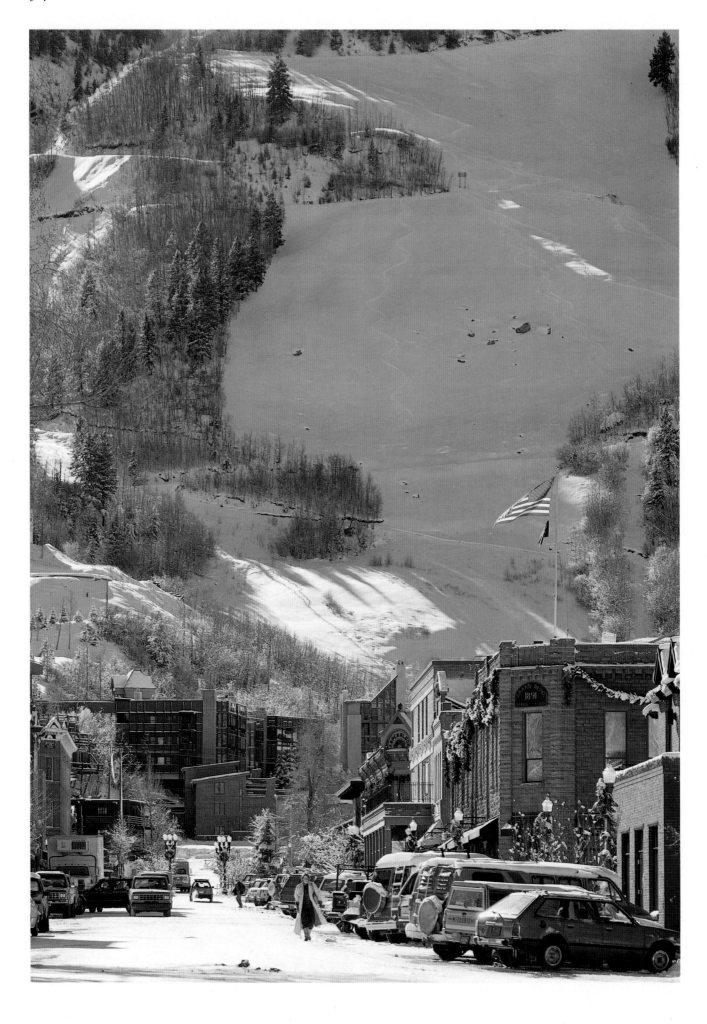

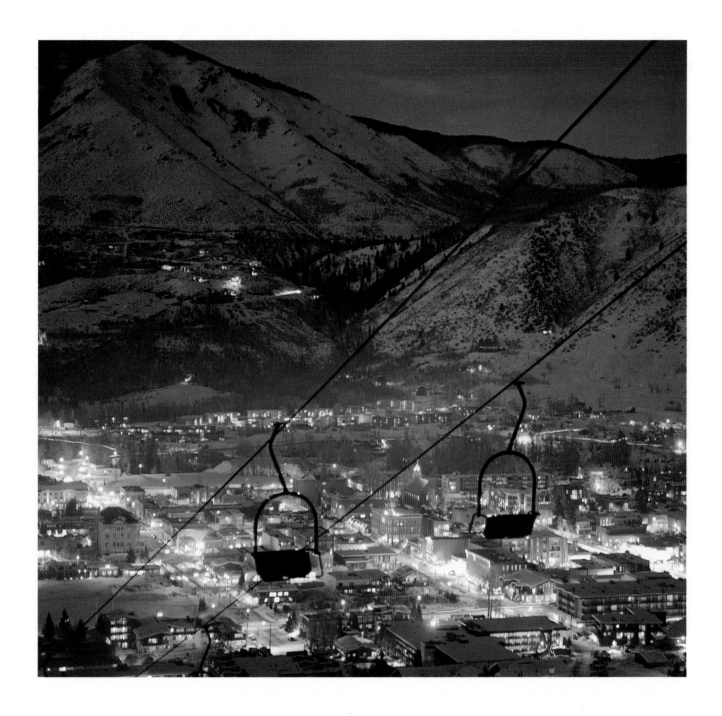

Day or night, Aspen has a character all its own during the winter months. Snowfall brightens the townscape with layer upon layer of fresh, white powder. The ski slopes come right into town as viewed from Galena Street. A nighttime view from Aspen Mountain, with Lift 1A in the foreground, shows the town brightly lit and festive.

Aspen is a pedestrian-sized town where walking will get you anywhere downtown within minutes. For longer trips the town's bus system offers free local service from the Rubey Park bus terminal pictured above.

RIGHT The Red Onion, built in 1892, first called the Brick Saloon and regaled as a popular brothel, was one of the town's first restaurants established to serve skiers. It represents Aspen's history and is one of many artfully preserved originals.

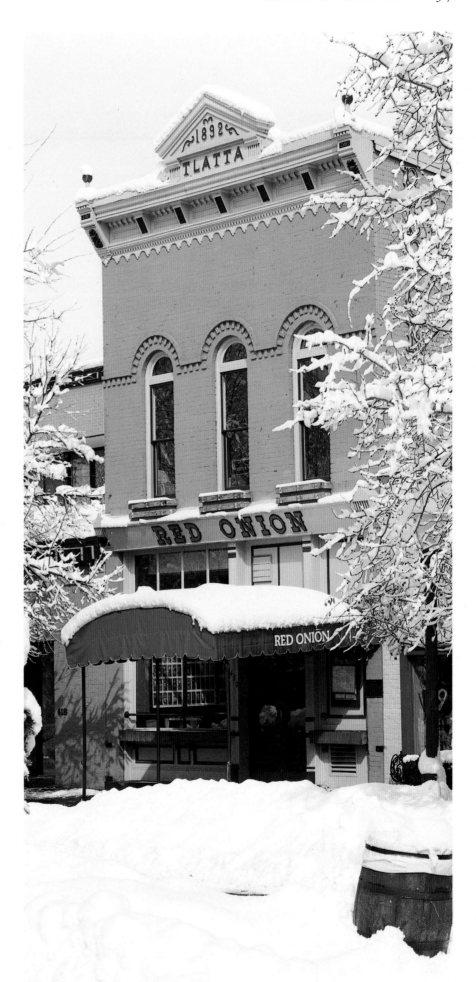

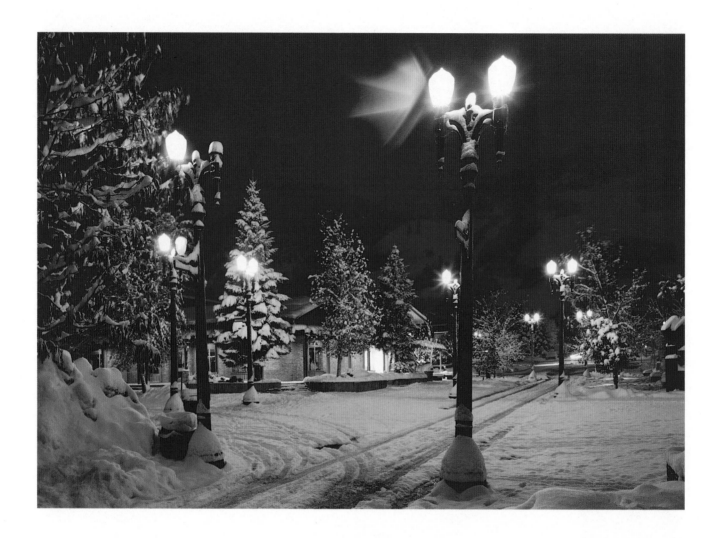

Winter is a quiet time during an early morning on the Mill Street Mall, where street lamps glow in a small-town setting.

RIGHT The Dickens Carolers, a local caroling group, share their Christmas cheer with Aspen as they serenade the town from the front steps of the historic Sardy House with John Denver and his wife Cassandra. The Sardy House today is a fashionable lodge that was built in the Queen Anne style in the early 1890's.

OVERLEAF Horses romp through fresh snow at Cozy Point Ranch west of Aspen. Once a strong agricultural valley, the Roaring Fork has few working ranches left today. Most of the horses are for pleasure riding, polo or hunting now that agriculture is no longer a viable economic pursuit.

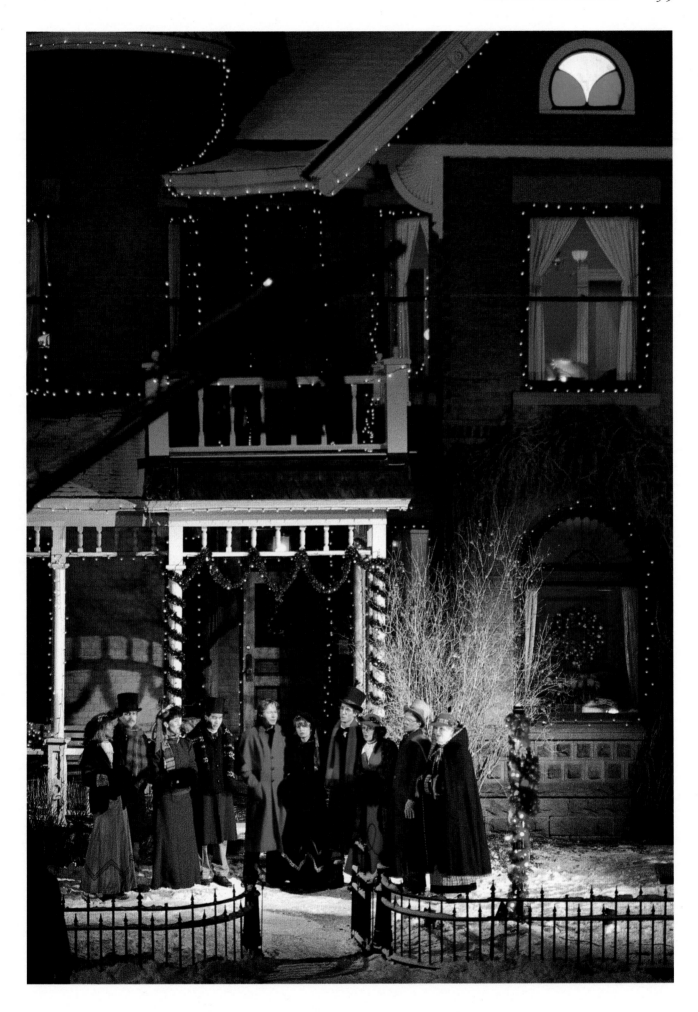

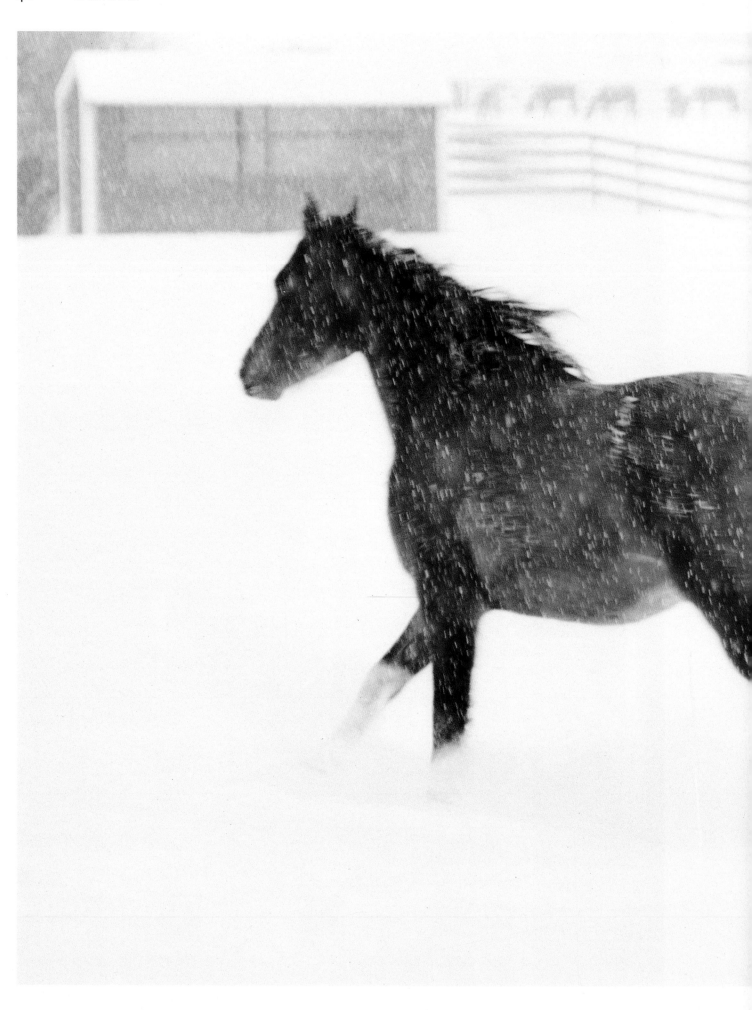

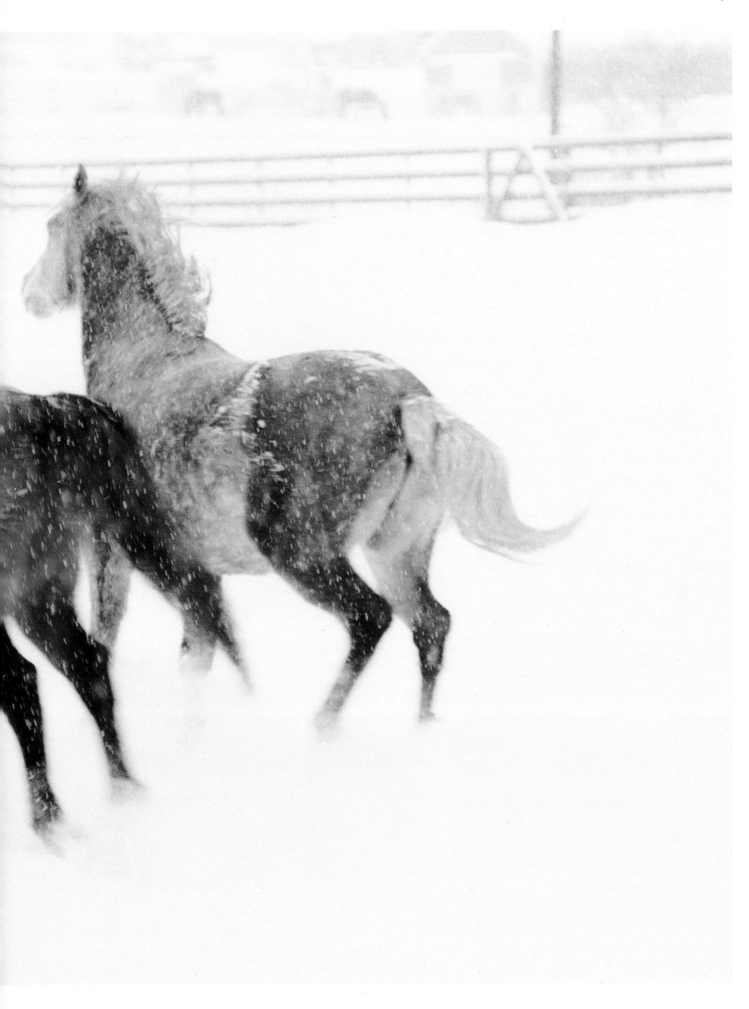

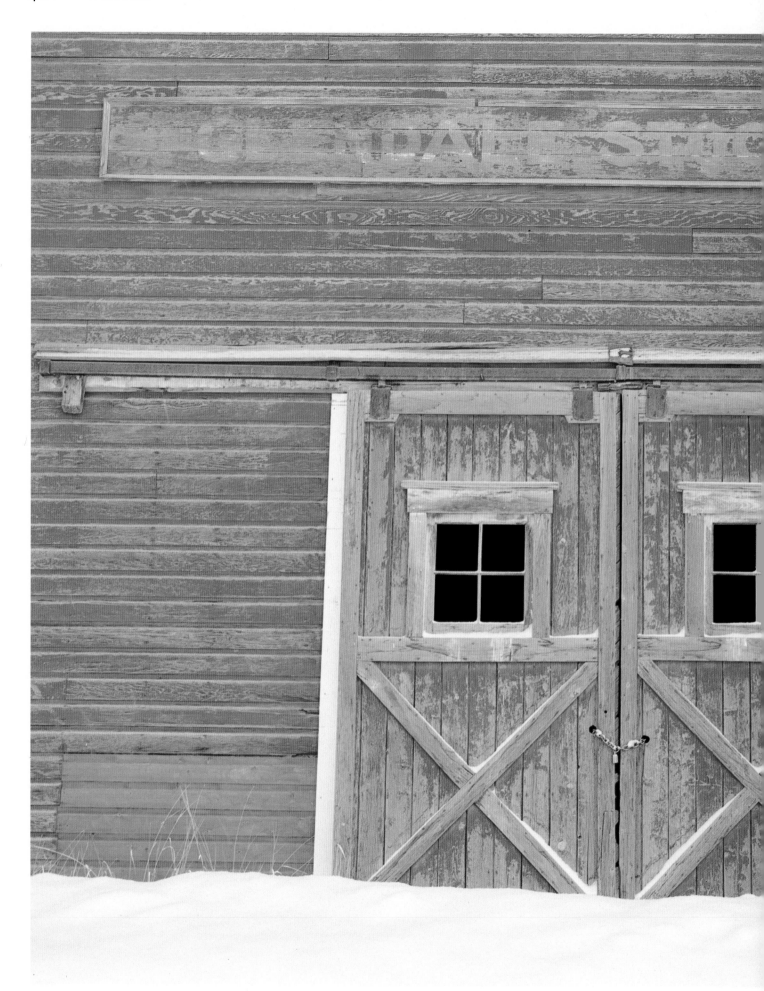

The old Christiansen barn on Owl Creek provides a popular reminder of Aspen's farming past. The farm implements have been auctioned off by Nels Christiansen, who is a direct descendant of the family that settled the property in the early part of the century. The Owl Creek Valley is a cherished valley for luxury home development.

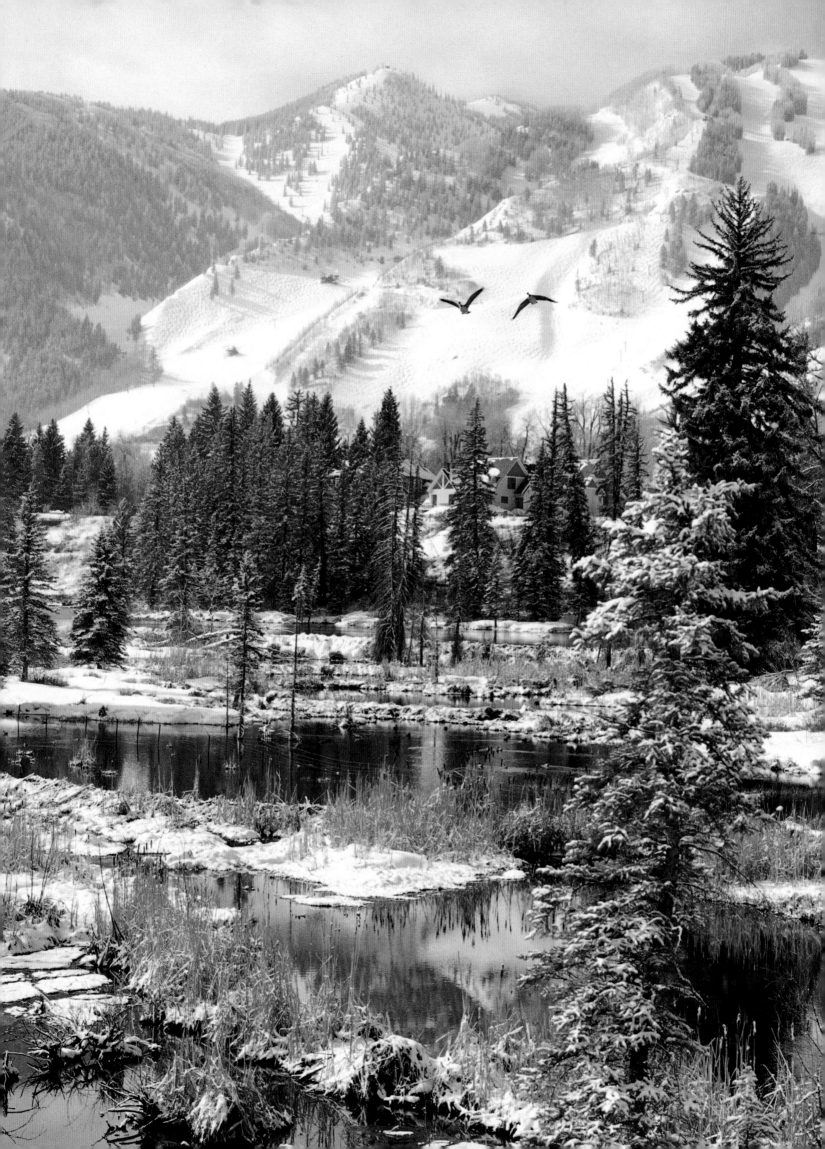

SPRING

Geese take to wing over Hallam Lake in Aspen on a spring day. The 22-acre lake lies within the city limits but is a quiet refuge for wildlife and the home for the Aspen Center for Environmental Studies, founded by Elizabeth Paepcke in 1968. The Hallam Lake Sanctuary and its facilities provide year-round indoor and outdoor classrooms for educational activities for children, adults and naturalists. Aspen Mountain's ski slopes in the background are the only indication this sanctuary is not hidden within a remote wilderness.

The thaw brings a quickening of the water. A gradual intensification of its roar may be heard from a ridgetop or felt through the ground near a stream bank where it pounds with brute force. Once the warming sun has drawn away the deep, snowy blanket green shoots poke skyward, the skunk cabbage, or false helibore, the Pasqueflowers, glacier lilies and irises. Skiers hike for the remaining snowpack, treading on a firm morning crust and carving turns in perfect, softened corn snow. The robin is a harbinger of the season and the meadows and fence posts are his for a while. As a painter might play with colors on a canvas the procession of green shades brightens the mountainsides. The rebirth occurs in Aspen with a hush of quiet as residents and tourists alike flee to warmer climes. Others busy themselves with ladder, paintbrush, turpentine, hammer and saw. Windows are open wide for fresh air. The sand and grit tracked in with the last snow is swept from the front room with a brief cloud of dust. Gone.

BELOW The Pasqueflower is one of the many harbingers of spring in the high country, often pushing through the last layer of snow to seek the warmth of the spring sun.

RIGHT From the ridge of Mt. Sopris (12,953 ft.) water rushes from every nook and cranny during spring runoff, a seasonal purging of the mountain snowpack spurred by the hot sun. Rivers rise and the flow of water reaches a deafening roar as tributaries combine and eventually feed the roiled and muddy Colorado River.

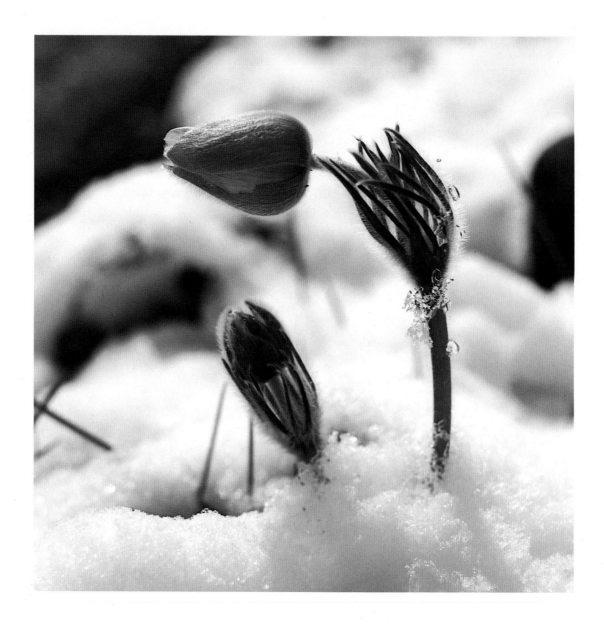

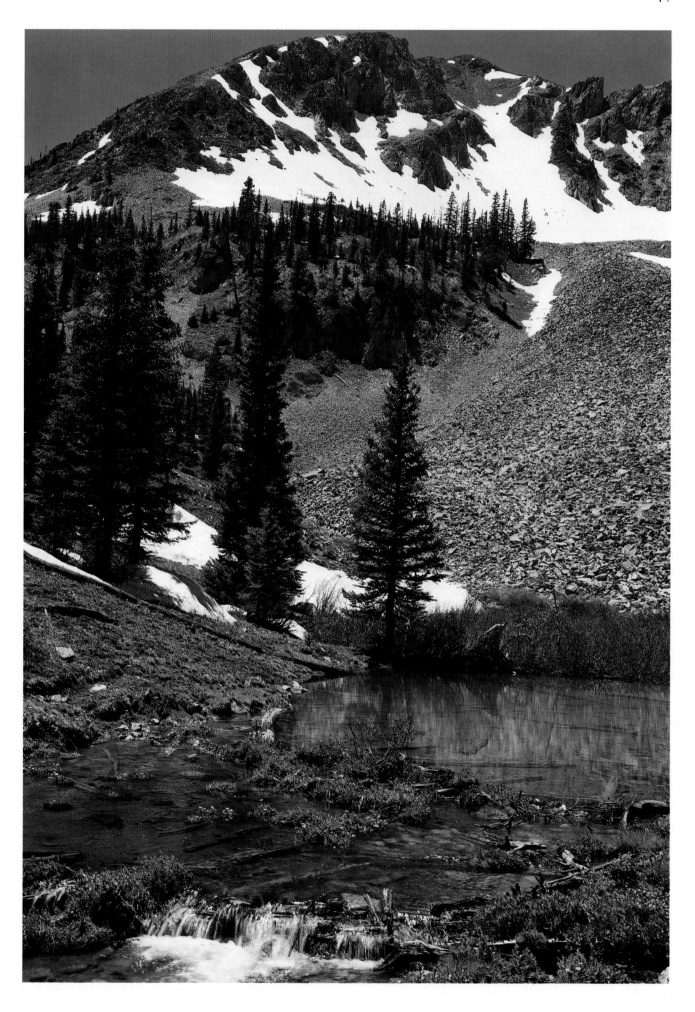

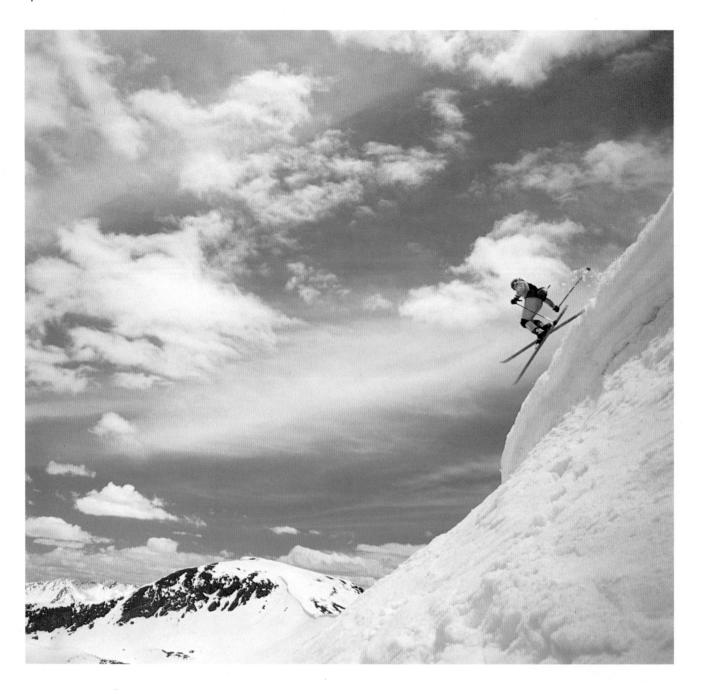

While spring signals the end of the season for most skiers, others are inclined to climb into the high mountains and make their last turns on sun-crusted corn snow. Here a skier gets air off a cornice in Mountain Boy Gulch near the top of Independence Pass, a favorite post-season ski run.

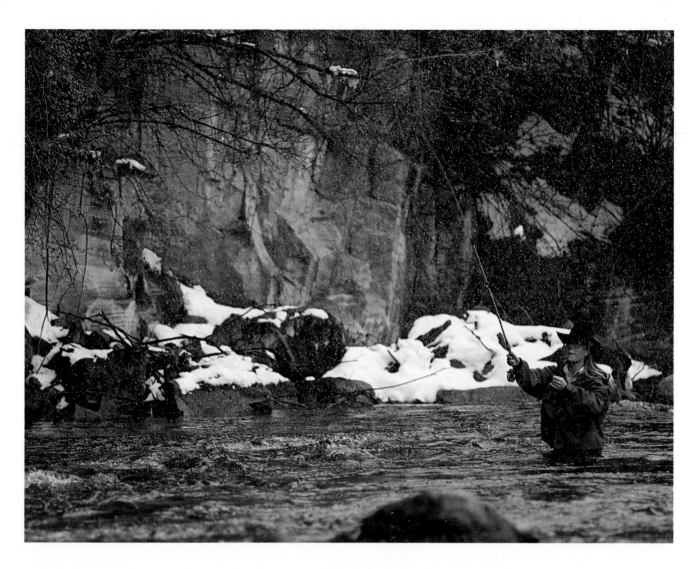

Wading rivers while snow still clings to the banks is a sign of a dedicated fisherman—or fisherwoman. But when trout are running, the challenge is enough to bring out the fisherman in many Aspen residents and visitors. Here a local whips the water with her fly rod, waist deep in the Frying Pan River, a gold medal stream about 20 miles from Aspen.

OVERLEAF The Maroon Bells are Aspen's hallmark mountains and some of the most photographed peaks in the world. As spring snows recede, hikers and backpackers explore the high country to marvel at wildflowers and some of the most spectacular scenery in the Rocky Mountains. Maroon Peak (right), at 14,014 feet, and the taller South Maroon Peak, at 14,156 feet, are notoriously dangerous climbs because of loose rock and insecure hand and footholds. Most visitors choose to walk the popular Crater Lake trail as it winds through aspen forest and alpine tundra.

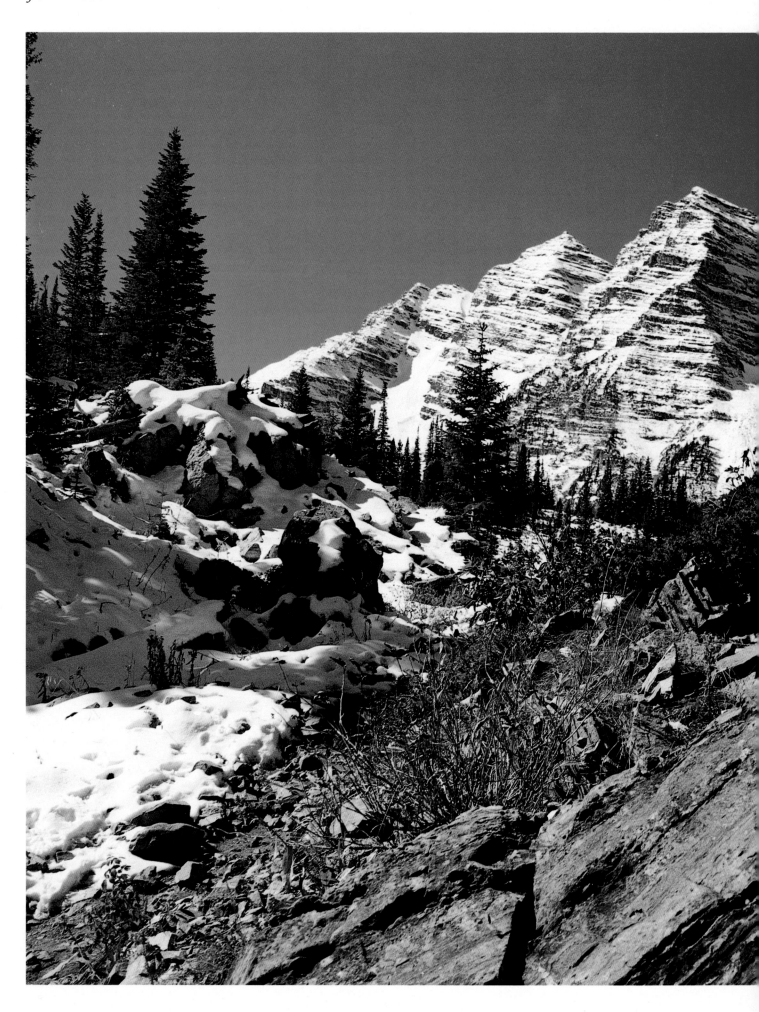

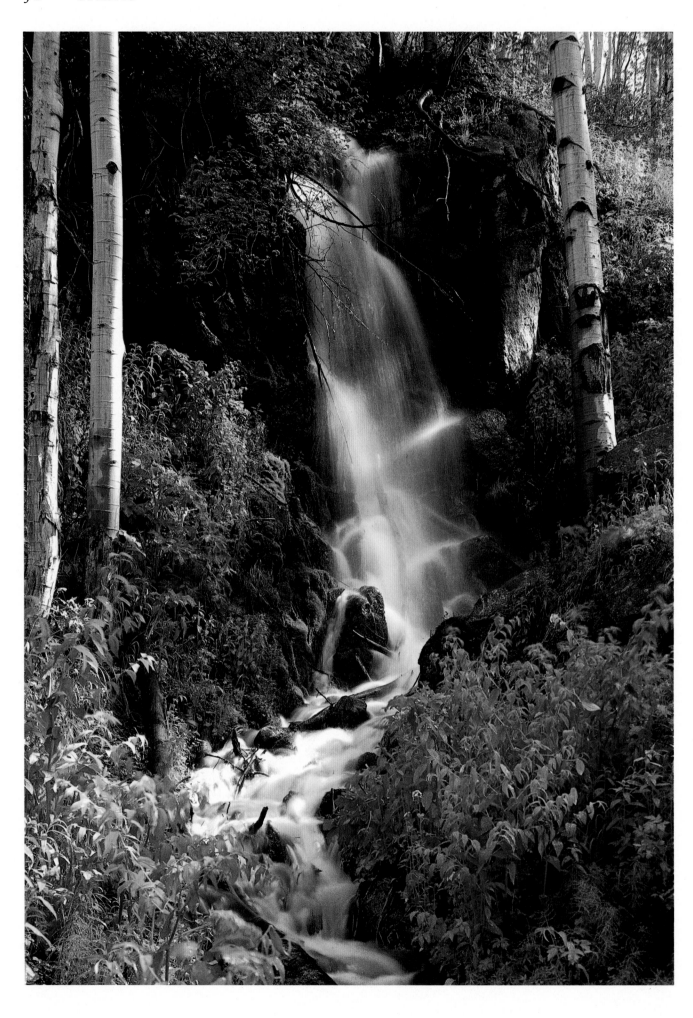

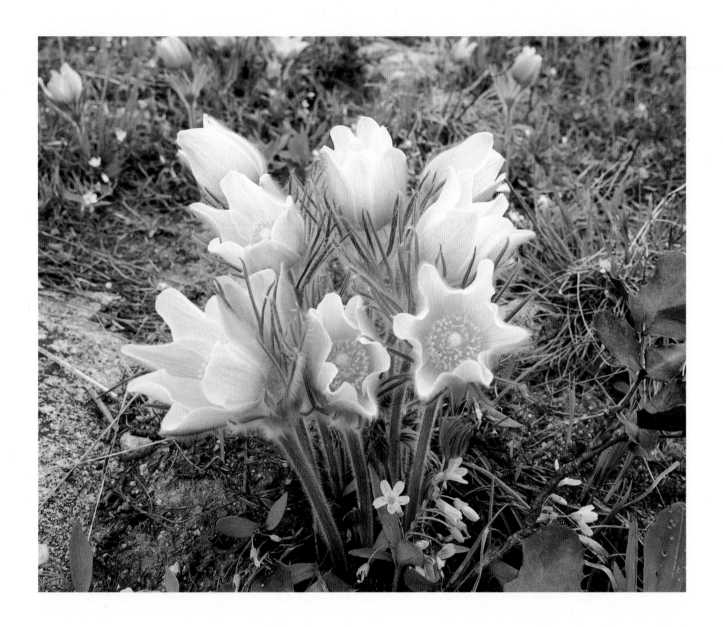

LEFT Cascades tumble through aspen forest verdant with spring foliage and studded with boulders near Weller Lake. A fine spray rises from streams as they plunge from rock shelves and follow the pull of gravity, rushing through the woods with a calming sound worth listening to on a day's hike.

ABOVE Pasqueflowers dazzle in a bright display of early spring. As a harbinger of the change of seasons, the Pasqueflower, a member of the Buttercup family, is a prized find for the hiker eager for summer. Normally a pale purple, this particular pink Pasqueflower is a rare mutant.

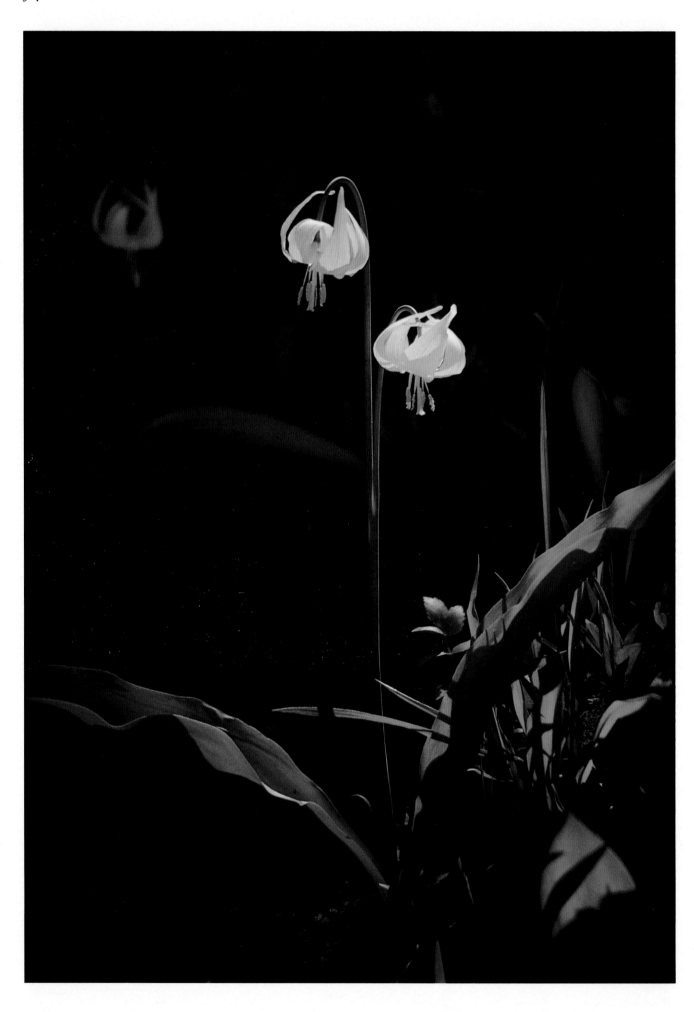

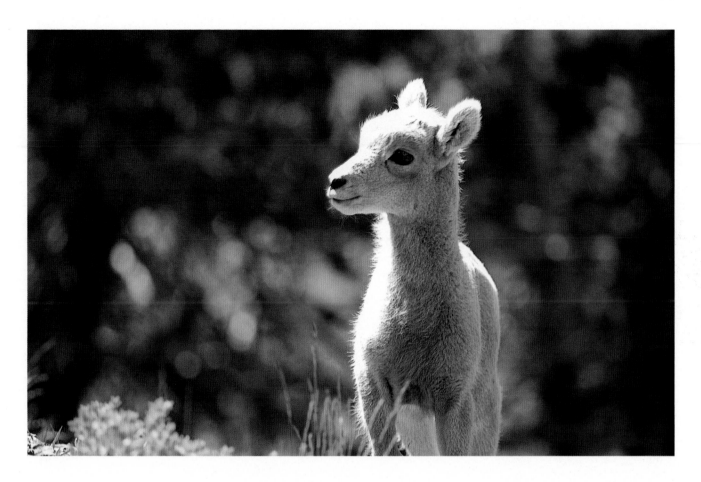

LEFT Glacier lilies near the Conundrum Hot Springs provide a splash of yellow on the carpet of green in a forest glade. These lilies, also known as snow lily and avalanche lily, grow from bulbs and follow with their bright blooms the retreating snowfields into the high mountains.

ABOVE Spring is a time for rebirth when the animals of the Rocky Mountains bear their young. Here a bighorn lamb tests its senses in a mountain meadow. These sheep are expert climbers and may be seen in the most rugged mountains, often on precipitous mountain faces where their sharp hooves afford them a sure grip.

OVERLEAF At 12,095 feet, Independence Pass is a literal high point for travelers entering Aspen from the east. Here the reflection of mountain peaks is captured in a small lake at the summit of the pass where motorists pause to take in the mountain tundra well above timber line. Independence Pass was the first route used by miners to enter the valley of the Roaring Fork. They often traveled by night during the spring, dragging their provisions over the crusted snow on crude sleds.

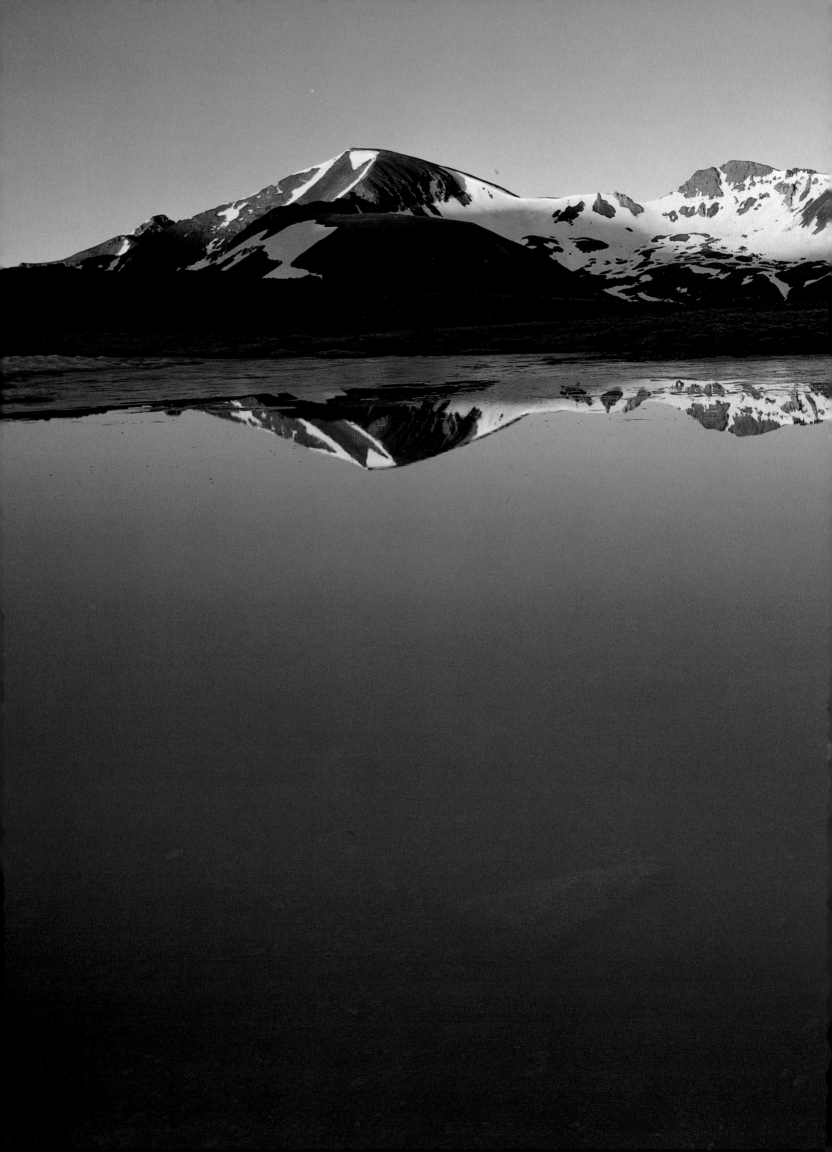

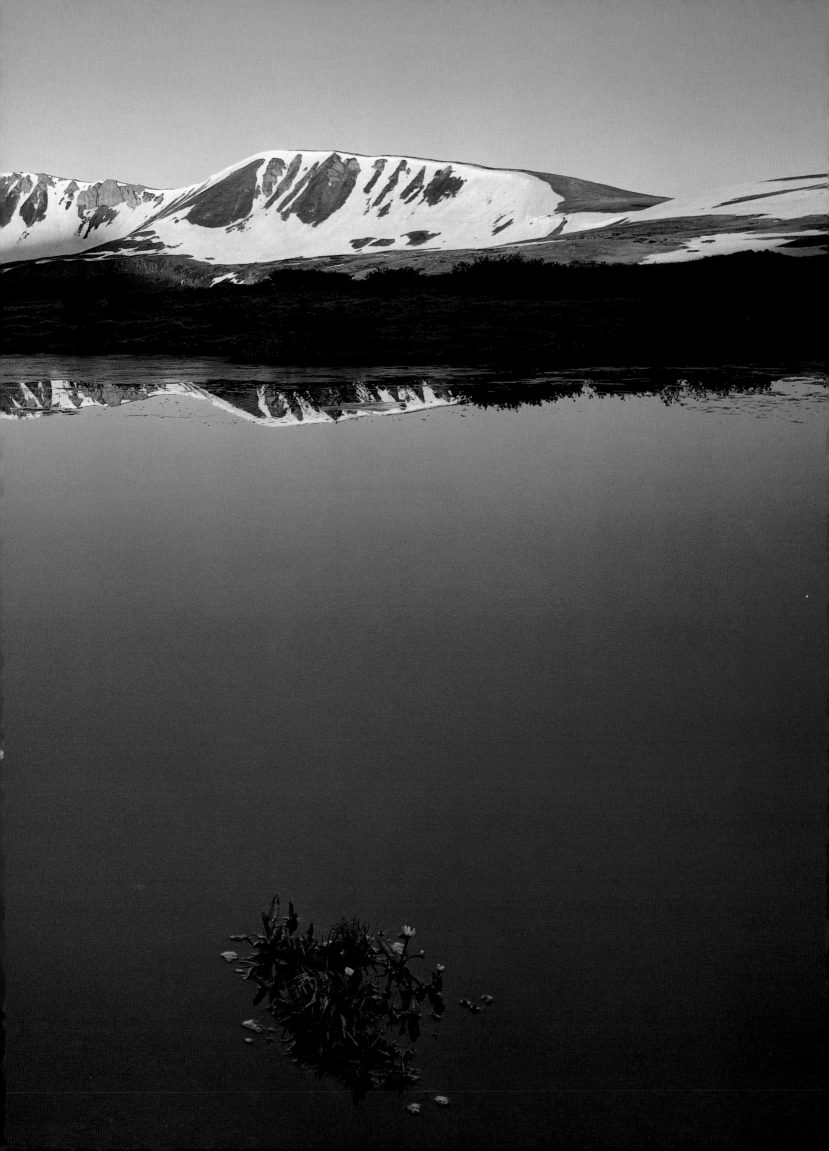

The Cooper Street Mall is quiet during the spring off-season, an unofficial grace period between winter and summer when Aspen is deserted by tourists and local residents alike. The resulting lull is a pleasant and refreshing change from the hectic months of winter. Spring is a traditional time of rejuvenation in Aspen when residents range from the Utah desert to Caribbean beaches in search of sun and warmth.

RIGHT Victorian architecture is often copied by new construction in Aspen in keeping with an architectural and historic tradition. This West End home is one of many neo-Victorians whose gingerbread façade is an oft-repeated cliché and a reminder of the 1880's.

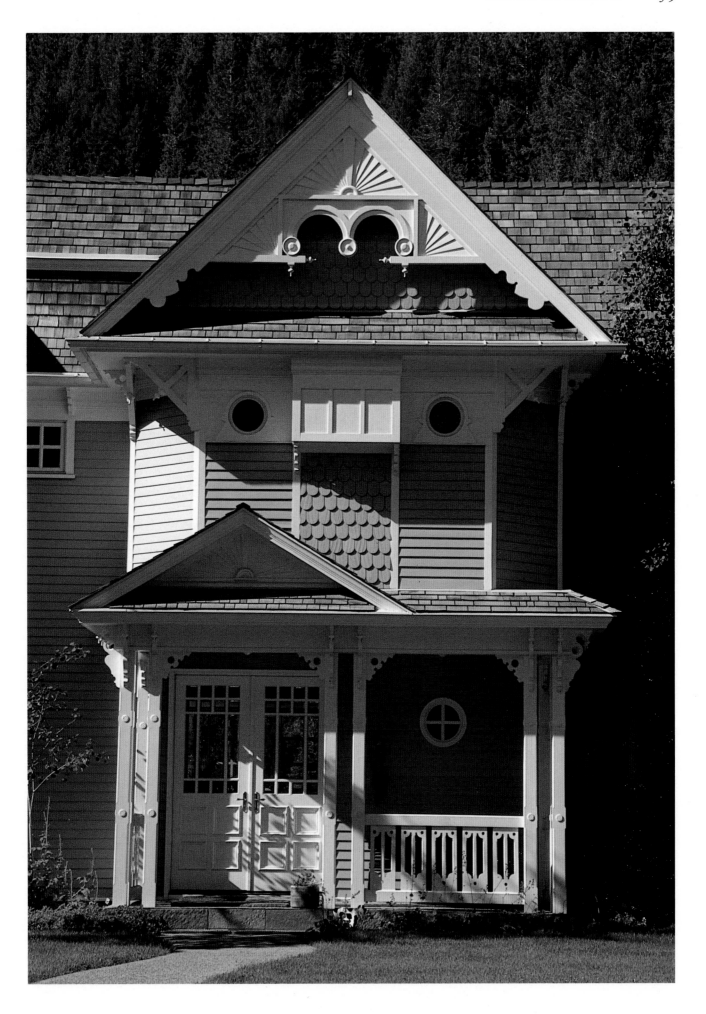

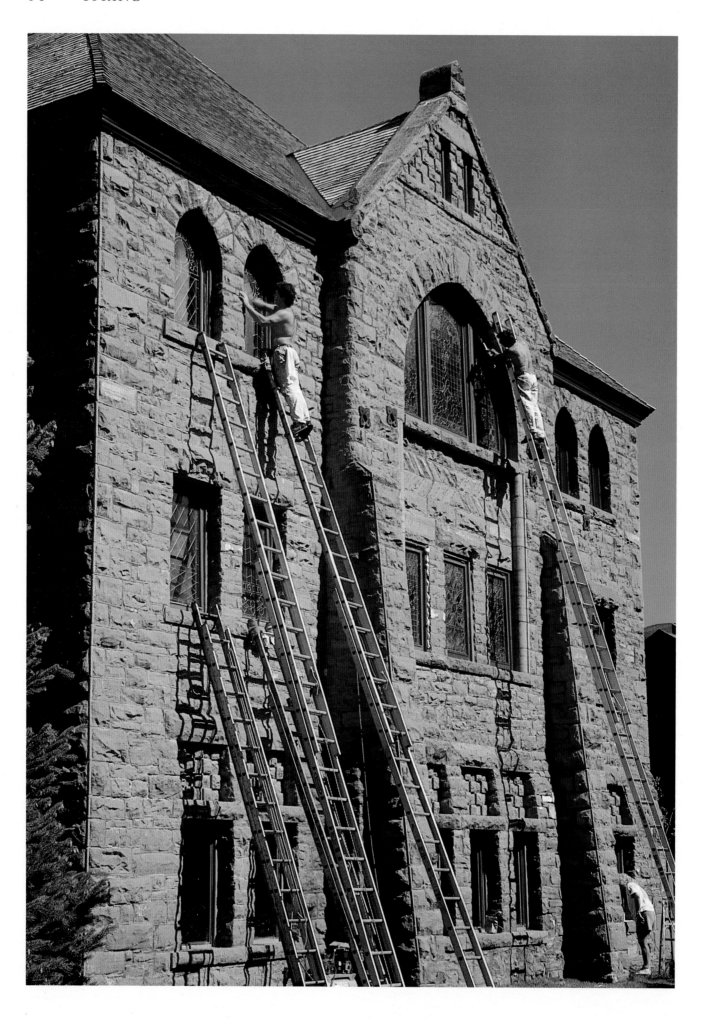

LEFT The Aspen Community Church, or First Presbyterian, was
built in 1890 and has served the community for a century as a
meeting place and a center for family worship. The large
sandstone blocks were quarried in the Frying Pan Valley and the
interior is highlighted by semicircular oak pews able to seat 350.
This and St. Mary's Catholic Church are the only surviving 19th-
century churches.

BELOW Still the seat of county government and home to the
courts, the Pitkin County Courthouse stands a regal part of
Aspen's history. Completed in 1891, the courthouse was designed
by the noted Denver architect William Quayle. An opening
ceremony included speeches and featured a traditional ball.

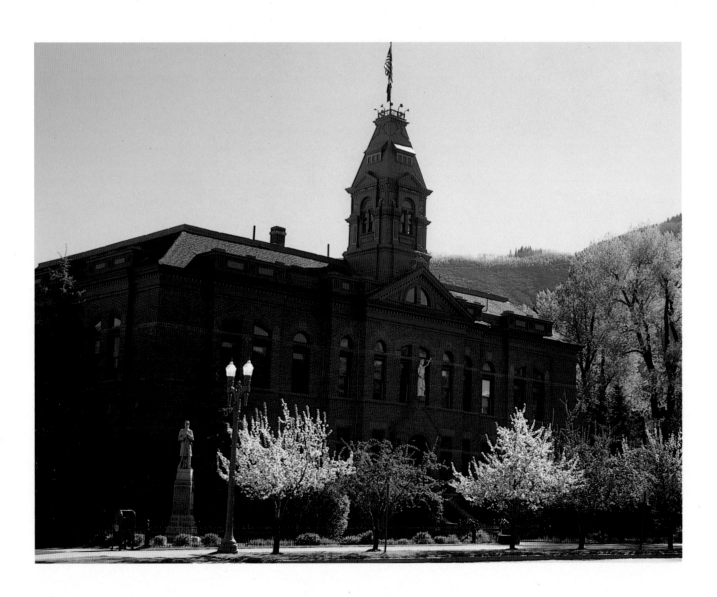

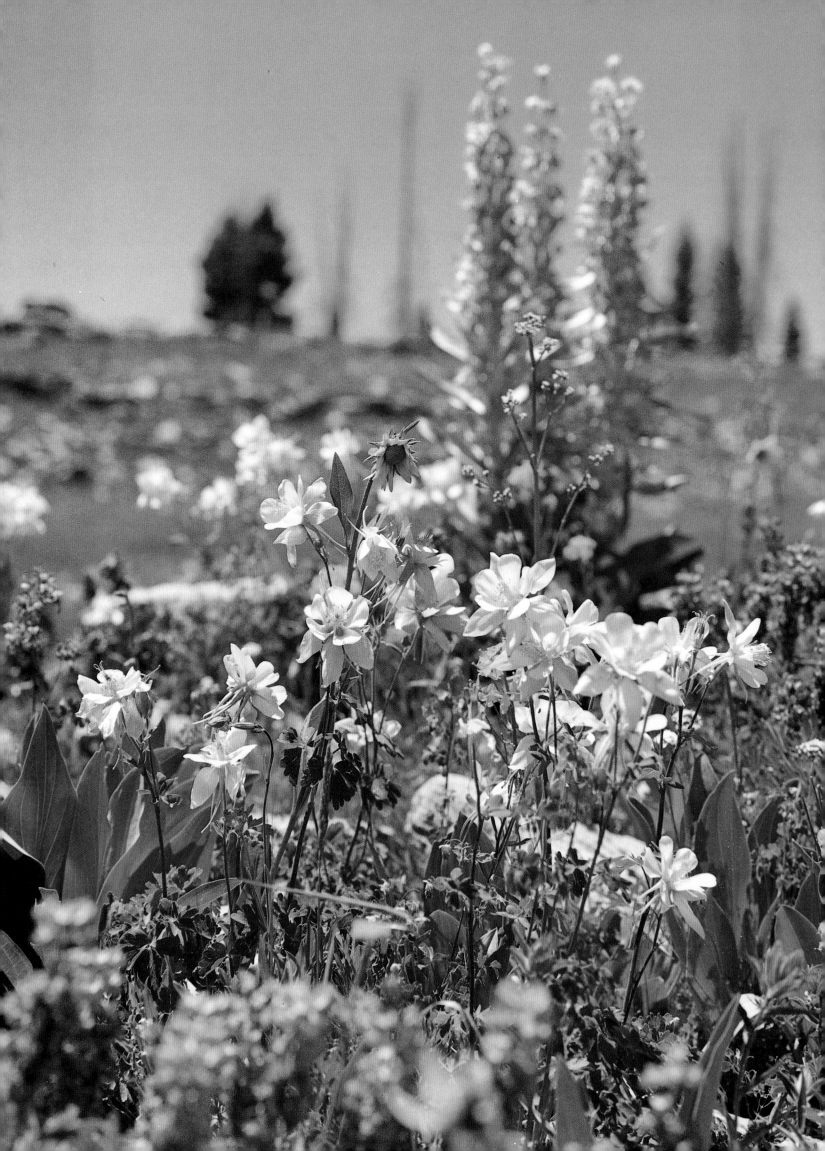

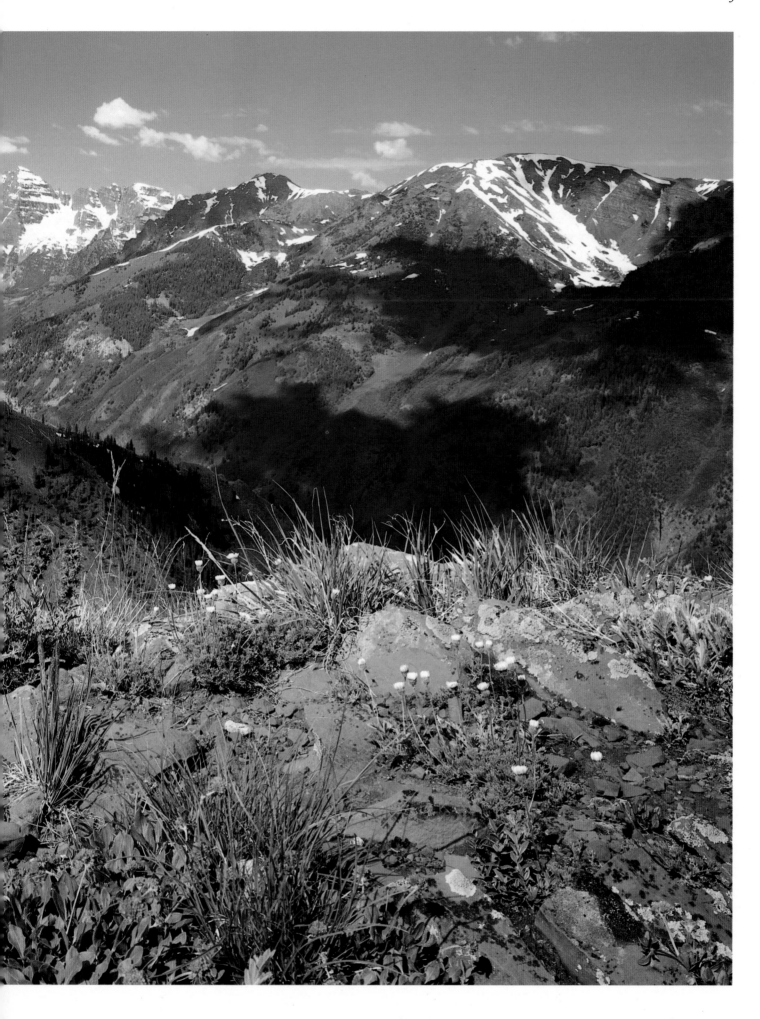

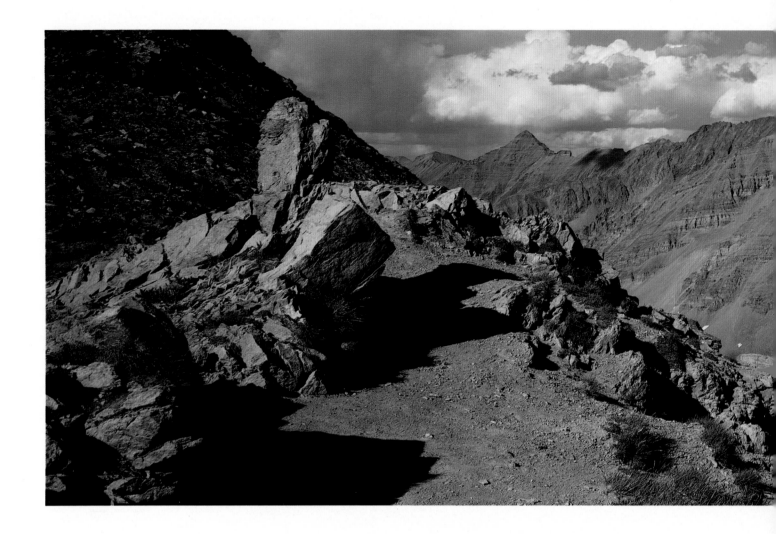

PRECEDING PAGE Pyramid Peak (left) and the Maroon Bells are bookend mountains in the Maroon Creek Valley when viewed from Picnic Point on Aspen Highlands Ski Area. All three of the famous mountains are above 14,000 feet and are favored from this vantage point for their stark, vertical rock faces. Picnic Point is a favorite during the winter, when skiers pause to look over the deep valley below.

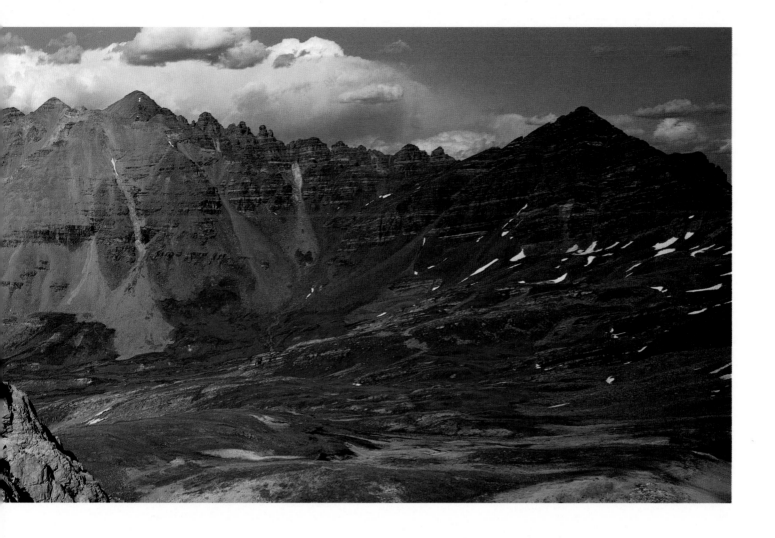

ABOVE At the abrupt end of the Conundrum Valley lies Triangle Pass where a rugged, high mountain view is just reward for the long hike. Twenty miles from Aspen, Triangle Pass is a gateway to Crested Butte, which is only a day's walk from the summit. Here the hiker is in the midst of the Elk Mountains and privy to one of the finest alpine experiences in the region.

OVERLEAF From East Maroon Pass, Copper Lake is a gem set in an emerald green basin at timber line. White Rock Mountain is jagged and massive in the background. A tent pitched among spruce and fir trees shows how the human scale is dwarfed by the expanse of this vast alpine terrain on the edge of the Snowmass/Maroon Bells Wilderness Area.

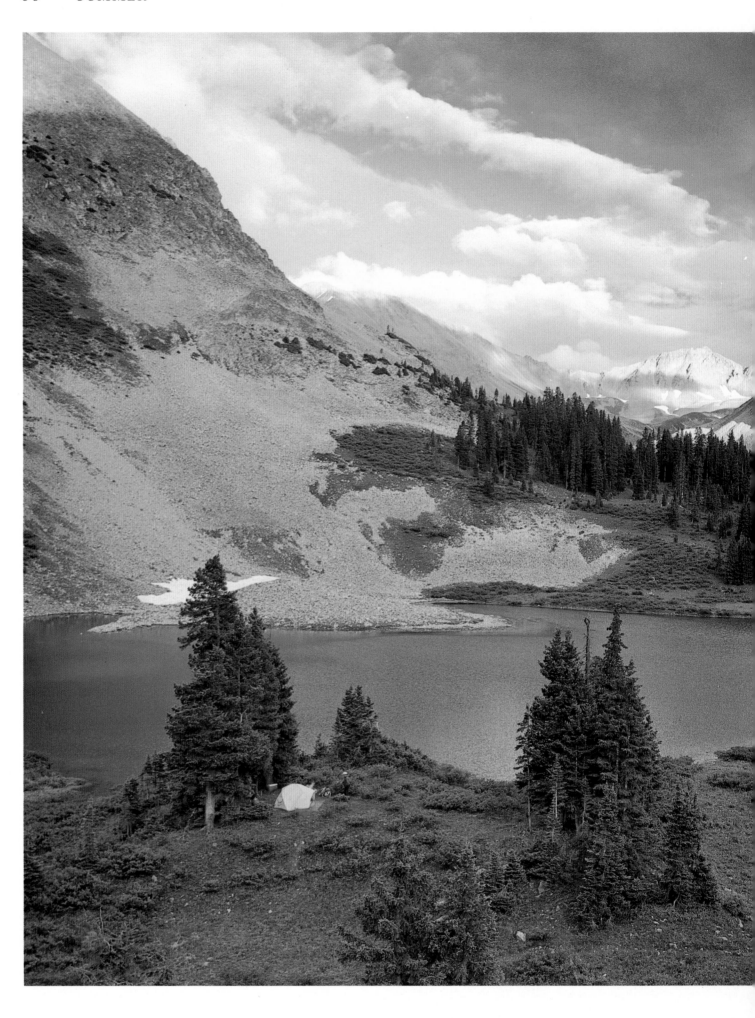

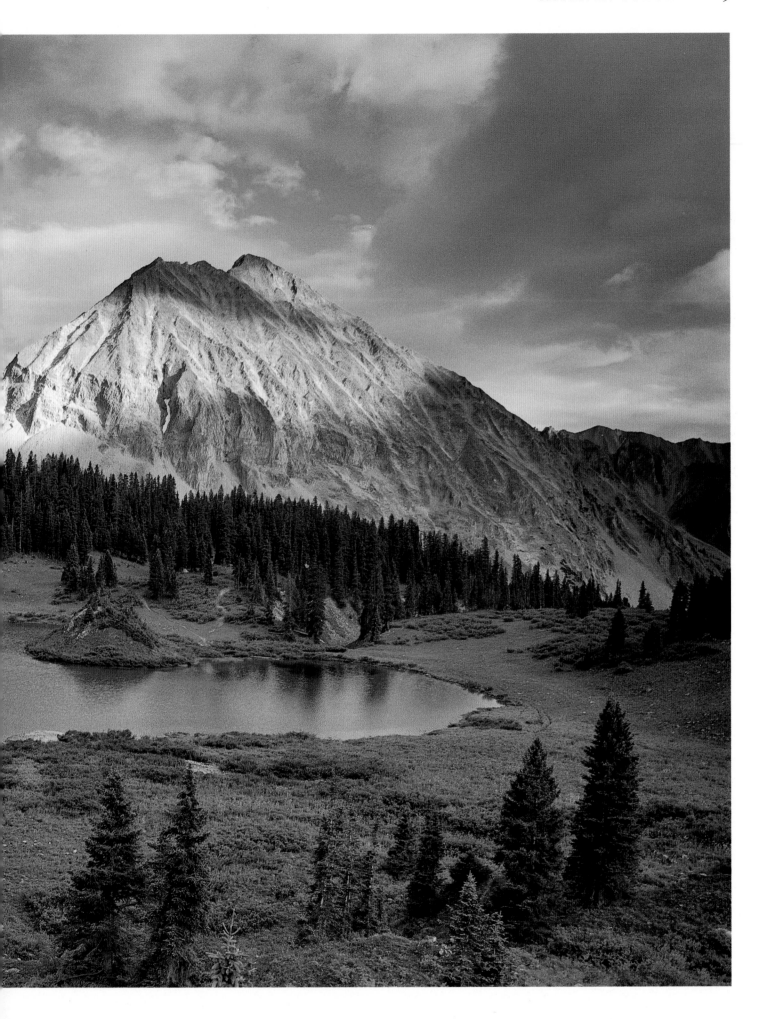

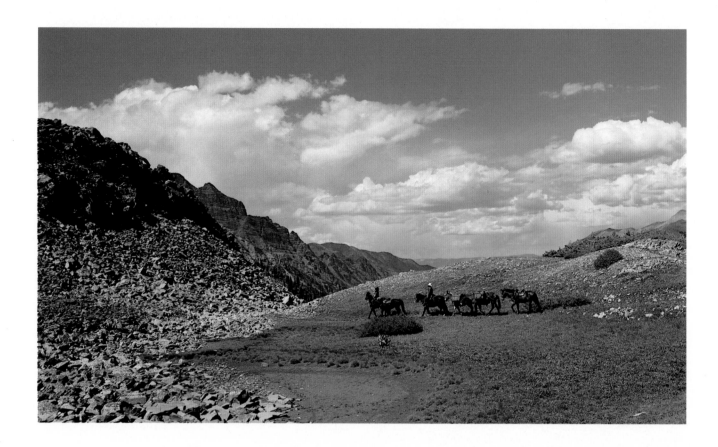

Horse packing near East Maroon Pass shows a traditional means
of travel. Early pioneers packed over the mountains between
Aspen and Crested Butte to explore mining claims and deliver
mail. Horse packing is less spartan than backpacking because
horses carry the loads, usually without complaint. Outfitters in
Aspen are available for day rides or multi-day mountain
excursions.

RIGHT A reminder that mountain weather is extremely
changeable comes with summer snowstorms. Here an August
snowstorm left a layer of wet, sticky snow at Maroon Lake. The
snow disappeared after a short burst of sun, evaporating into the
summer air. But anyone traveling in the mountains is warned to
prepare for the unexpected because weather changes rapidly and
can bring snow squalls when they're least expected.

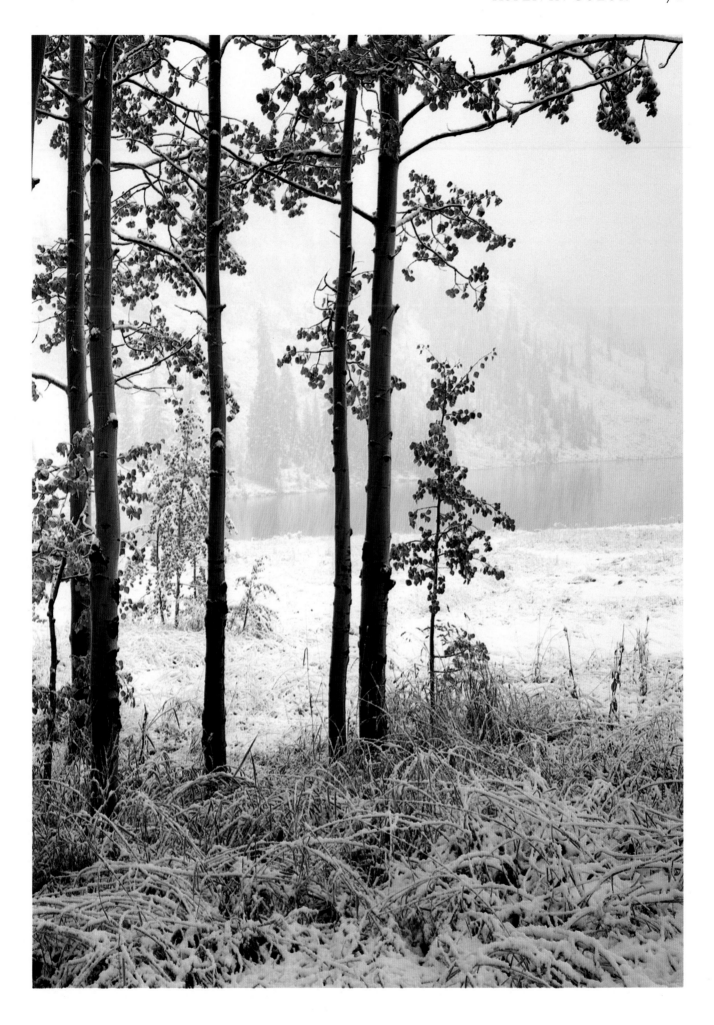

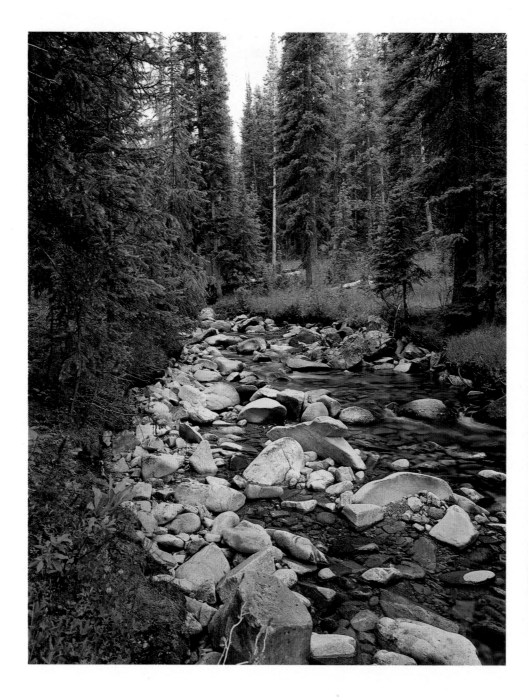

The Roaring Fork River bends and turns through its rocky course
and casts its charm on the Aspen area. The river begins in the
high mountains east of Aspen near Independence Pass, picks up
volume by collecting its main tributaries: Castle Creek, Maroon
Creek, Snowmass Creek, the Frying Pan and the Crystal River.
The Roaring Fork then meets the Colorado River at Glenwood
Springs. The water level fluctuates with the seasons, raging in the

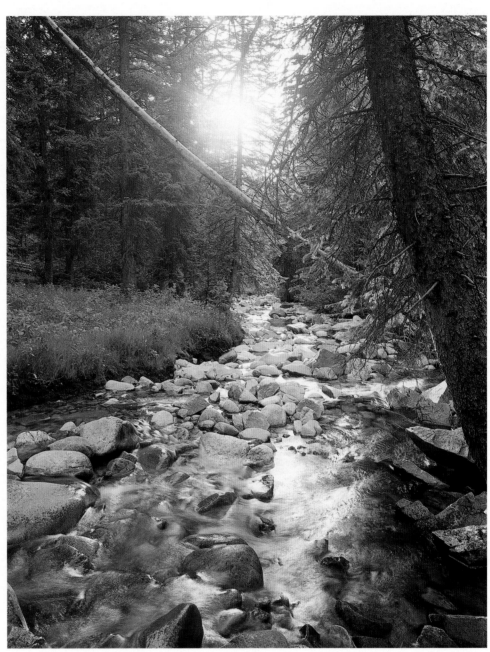

spring, then sedate in late summer. The river is known for its fishing, kayaking and rafting.

OVERLEAF The rose crown, or queen's crown, flourishes near water. These flowers were growing from the crack in a rock with a spray of water cascading over them. They prefer marshes and bogs and are found in the upper reaches of the subalpine zone.

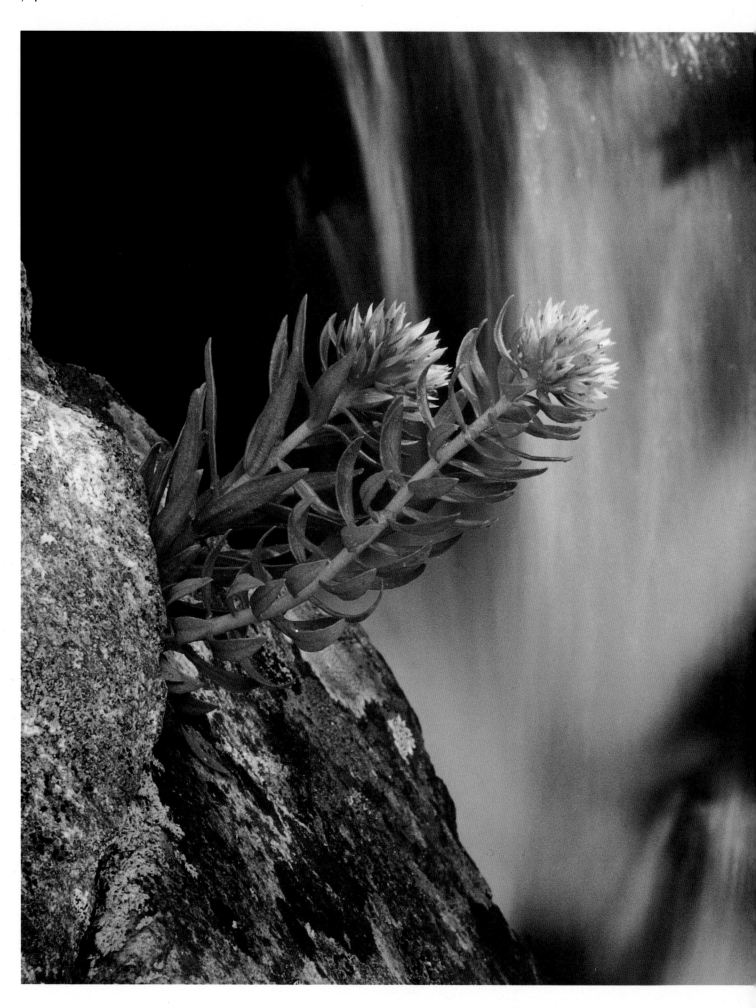

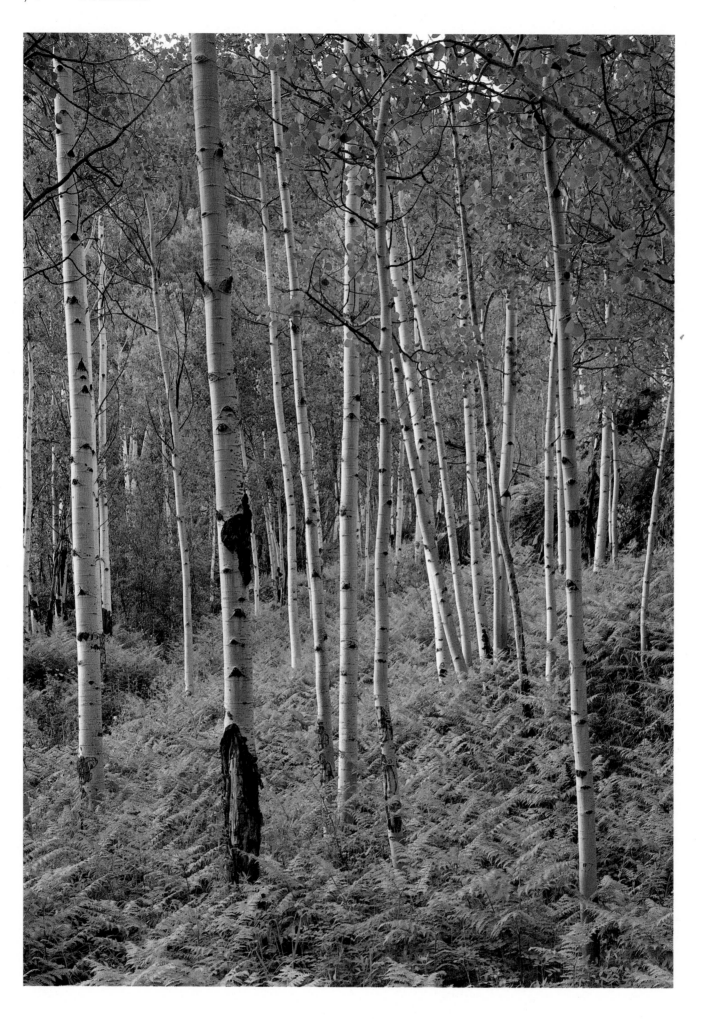

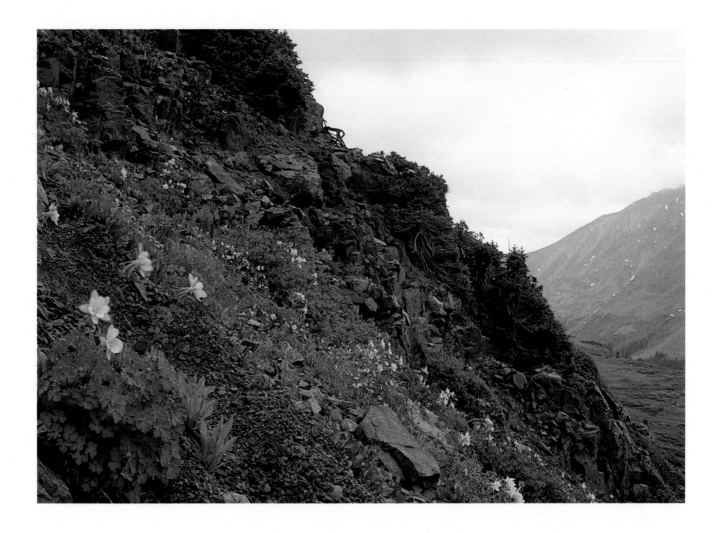

LEFT Fern and aspen are familiar and inviting to travelers in the Colorado high country. There is nothing quite so peaceful as a stroll through such an environment, lush and green and utterly inviting.

ABOVE The treasures of the high country sometimes require a little exploration. Here, on a steep gulch between Anderson and Petroleum Lakes, a variety of wildflowers blooms. The headwaters of Lincoln Creek gather in the valley below.

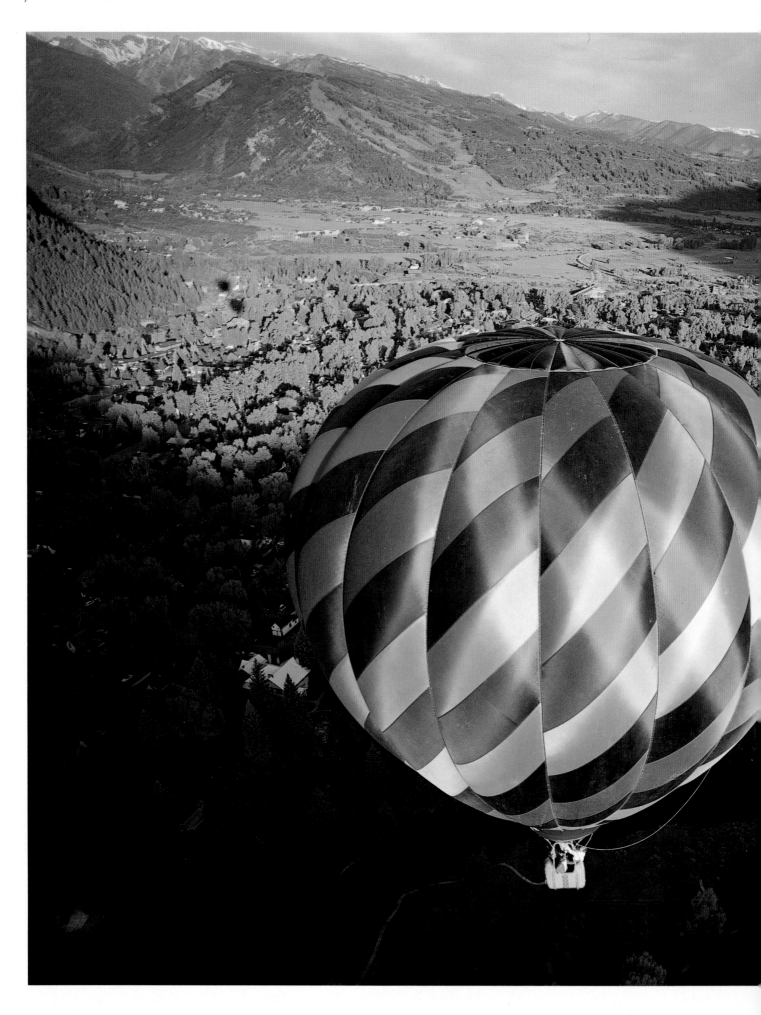

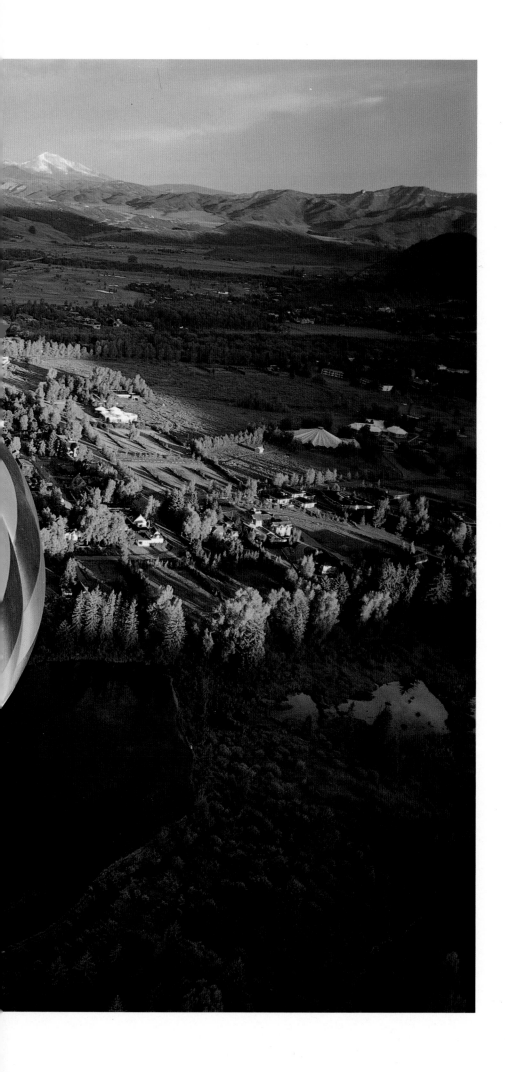

Early morning in Aspen is the preferred launch time for hot air balloons. By following the prevailing winds, a pilot may take his balloon upvalley or downvalley. By following air currents, balloons become a lofty and colorful means of sightseeing. This balloon rises over Aspen's West End. In the background is the Tiehack Ski Area and a snowcapped Mt. Sopris.

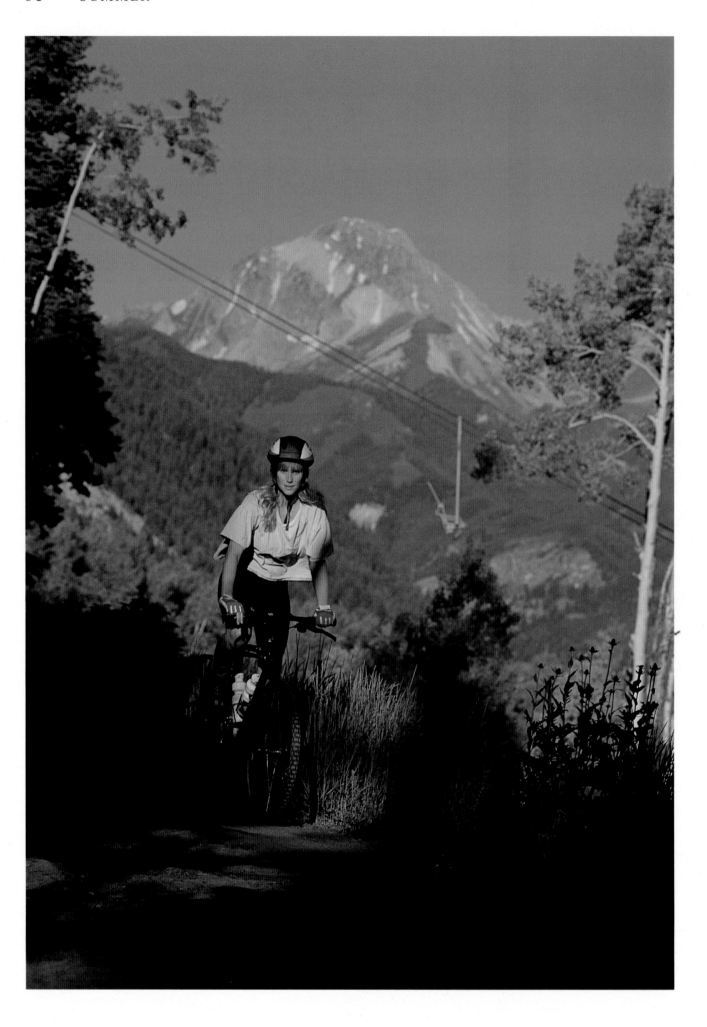

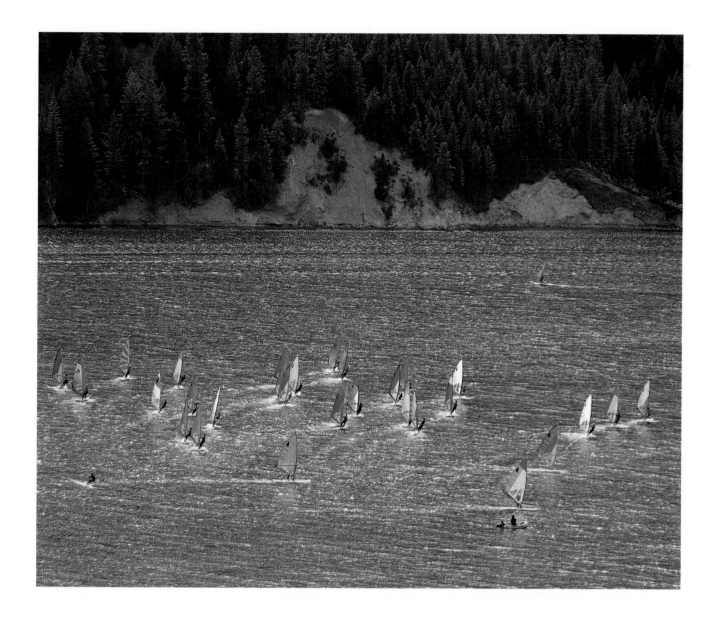

LEFT Mountain biking is a relatively new sport, but one that has taken off with incredible popularity. Many jeep roads and hiking trails outside of the designated Wilderness areas offer challenging rides. This biker is climbing the Snowmass Divide Road with Mt. Daly and a chairlift at the Campground area of Snowmass in the background.

ABOVE Windsurfing is a sport on the move and a popular pastime at Ruedi Reservoir where brisk west winds can offer good sailing. Ruedi is on the upper Frying Pan River about 20 miles from Aspen past Basalt.

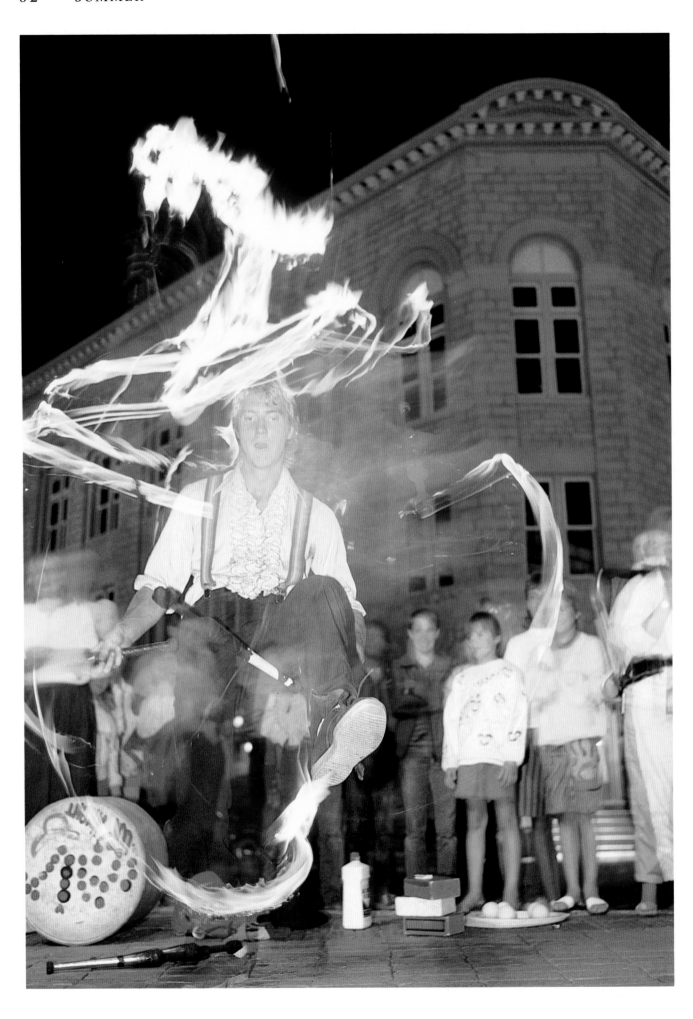

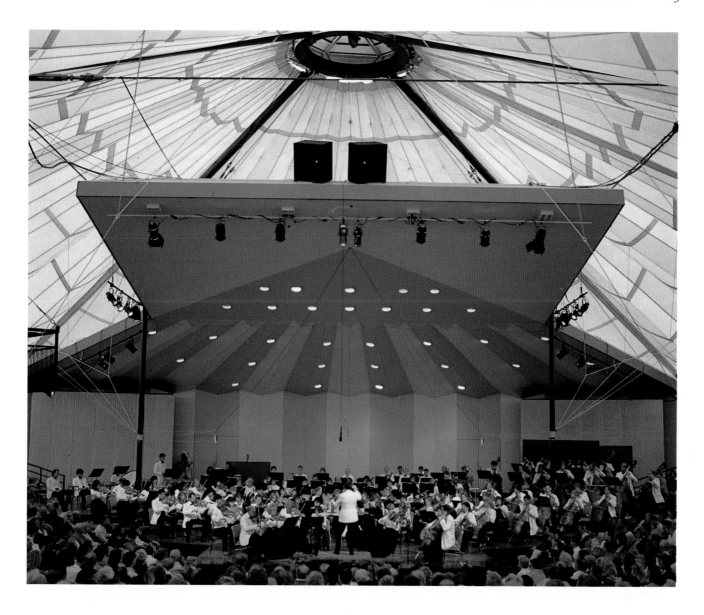

LEFT Aspen nightlife would not be complete without a juggler throwing flaming Indian clubs during an act on the Hyman Avenue Mall in front of the Wheeler Opera House. During the warm summer months crowds gather to watch jugglers, acrobats or to hear a brass quintet made up of music students.

ABOVE The Aspen Music Tent is the site of a summer program of classical music that was born as part of the Aspen Institute for Humanistic Studies over 40 years ago. World-class soloists, composers-in-residence and music students from around the world attend the nine-week summer session and perform up to several concerts per day. The Aspen Music Festival is world renowned and a haven for music lovers.

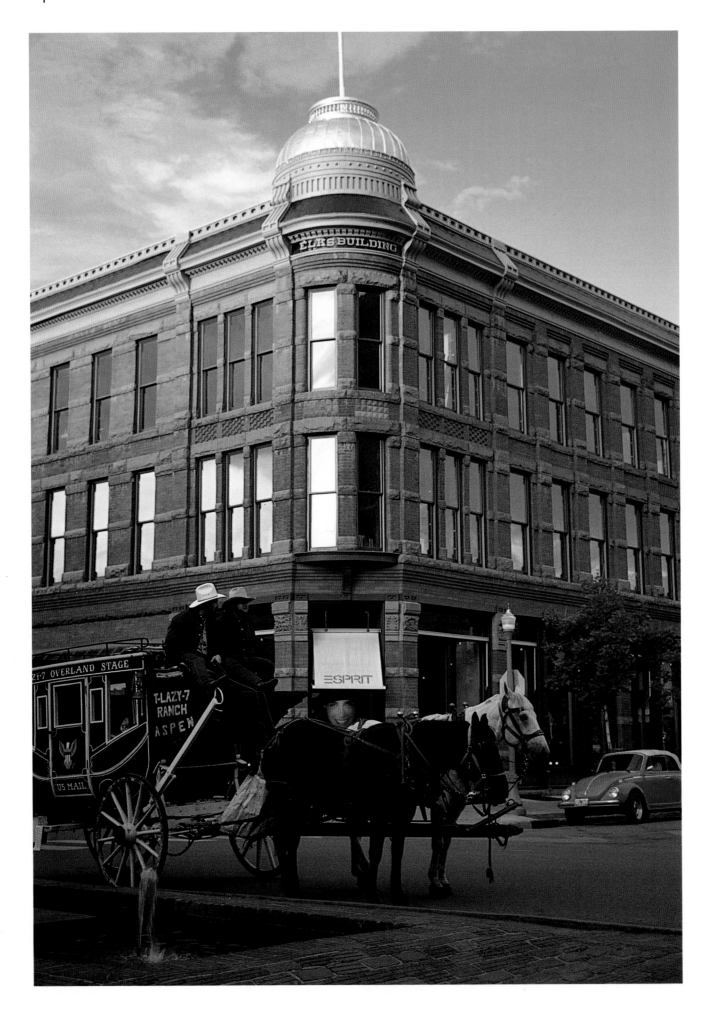

LEFT The Elks Building, or Webber Block, built in 1891 at a cost of $40,000, is one of Aspen's landmark structures. The building material is pressed brick and "peachblow" sandstone from the Frying Pan Valley. The Elks Club bought the building for back taxes in 1912 and have met there ever since. The building, remodeled in 1990, holds retail space for a number of shops and businesses. A stage coach and team of horses is often parked out front, waiting to take tourists on a ride around town.

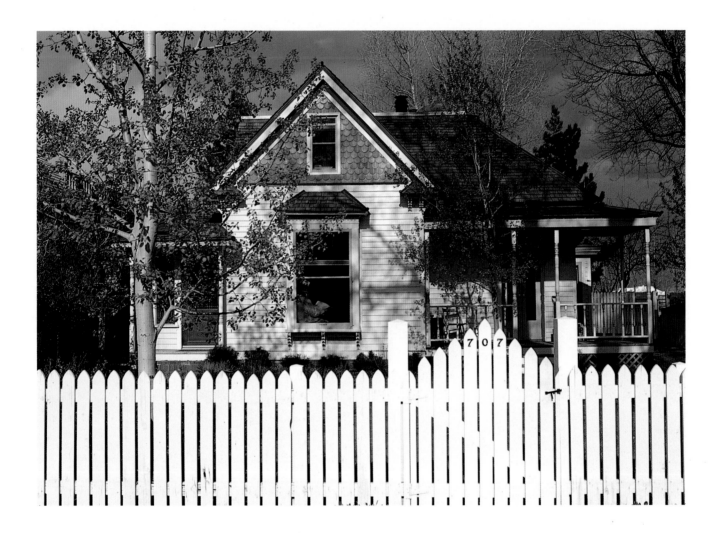

ABOVE A white picket fence fits well with an historic Aspen home. Following the crash of silver mining in the 1890's, properties like these were practically being given away. Today they command top dollar and often serve as second homes. Thanks to a strong preservation ethic, many such homes were saved and restored and today lend a sense of history to the town.

BELOW The Popcorn Wagon and Mill Street fountain are major summer attractions for those in need of a lemonade or a diversion. One of the most popular pastimes for children is testing the fountain's random spurts, usually at the expense of a good dousing.

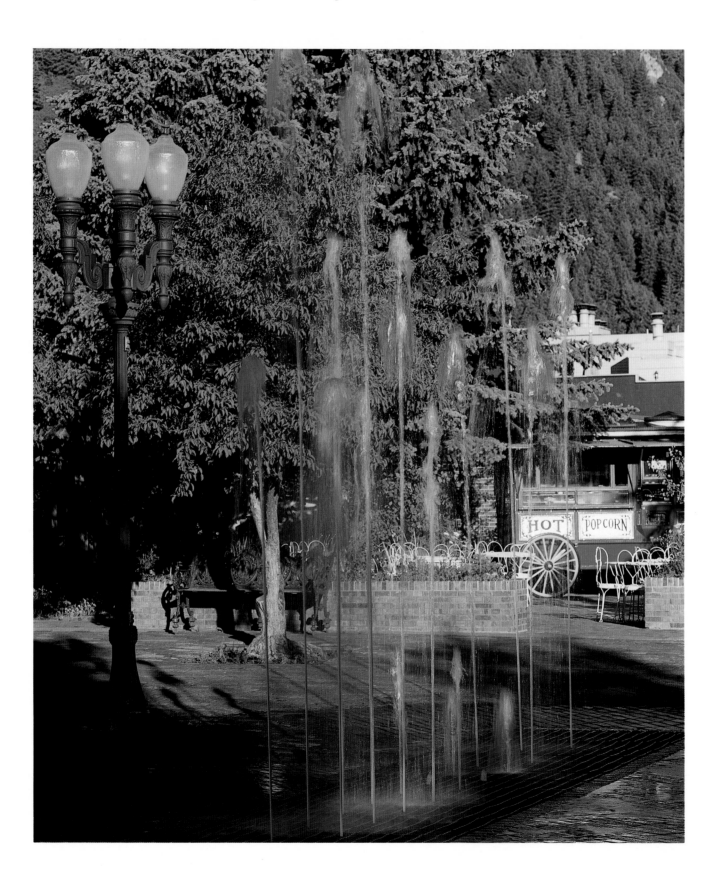

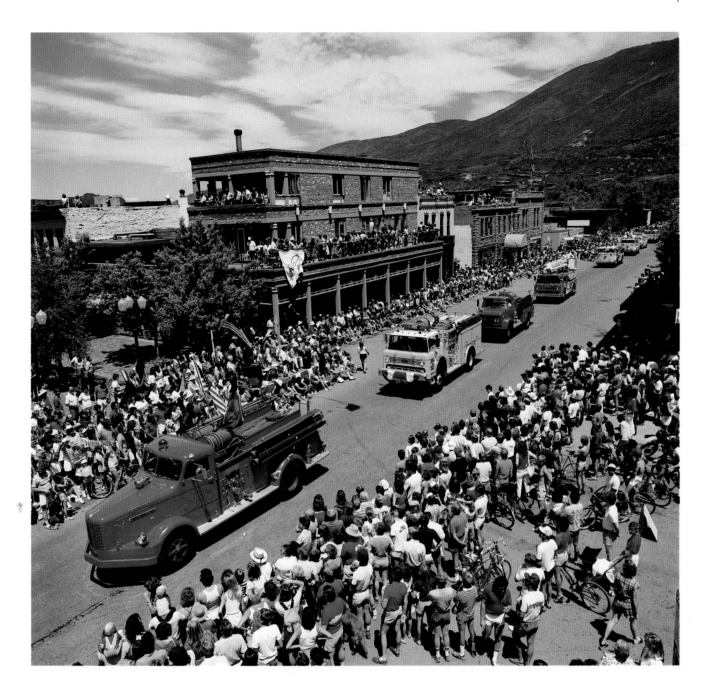

ABOVE Fourth of July in Aspen would not be complete without fire engines leading the parade, their sirens blaring. Aspen's volunteer fire department is quick to oblige by driving the fleet through streets lined 10-deep with folks gathered to view the Independence Day celebration as it passes Aspen Drug. On Galena Street, the parade heads toward Aspen Mountain, replete with marching bands and floats.

OVERLEAF The Snowmass Balloon Festival is held every summer and brings color to the Snowmass golf course as up to 50 balloons lift off. The launch takes place early in the morning when winds are light and the skies are clear.

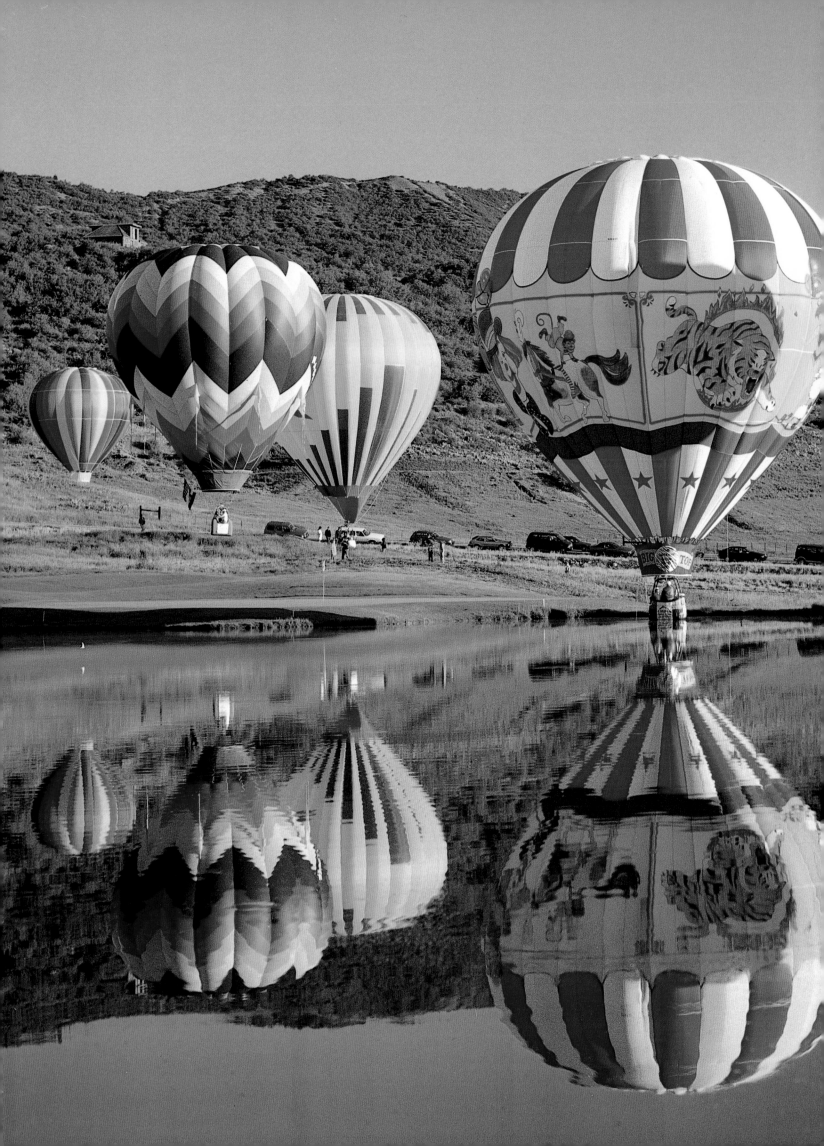

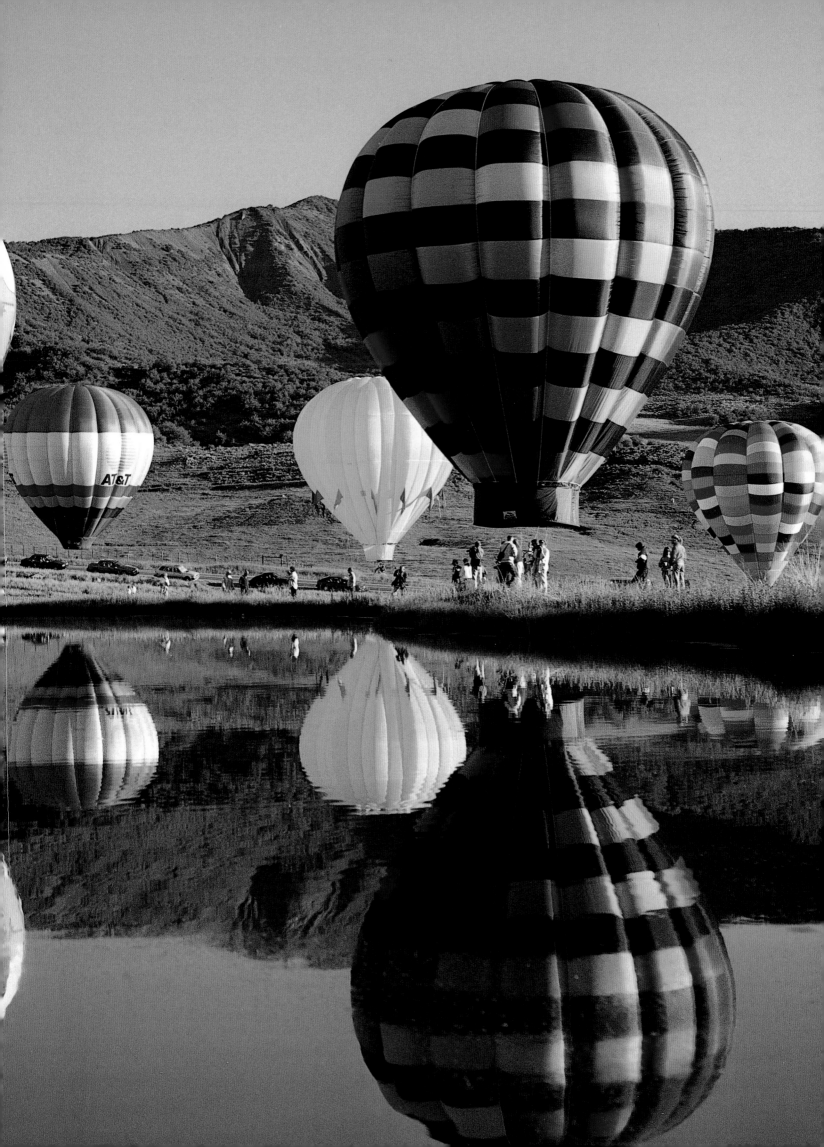

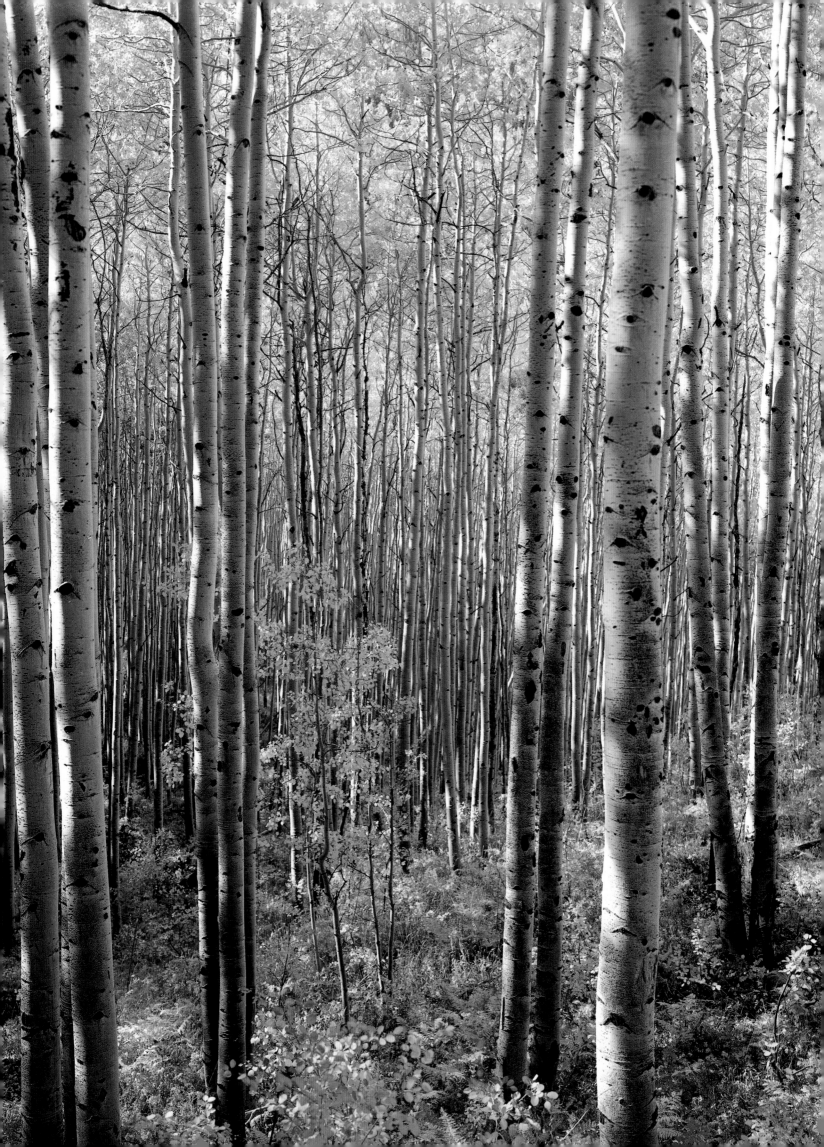

AUTUMN

The shift from summer to winter is one of the great delights. Although it means the end of an all-too-short summer in the mountains, it ushers in a stunning spectacle. The change occurs with a colorful pageant that bursts through aspen groves and ranges over mountainsides in a fairytale transition of green to gold.

Short days lead to long, crisp nights when frost burns the fern fronds, leaving them brown and dry like old lace. The floor of the forest crunches with dried leaves that make a fragrance sweet and pleasant. The animals are wary, their internal clocks signaling a change so profound the yearlings sense it but cannot comprehend. When the rains pelt the valleys there is snow left on the highest peaks, a white veil like powdered sugar that evaporates by noon. The aspen and cottonwoods are yellow-gold and shimmer in the wind like gilt. Autumn is a time of preparation, psychological and physical. Aspen gradually shifts gears from summer to winter and a new season quickens the pace. Snow and skiing are on everyone's mind while rugby is played in Wagner Park. The Music Tent comes down. The cottonwoods shed their leaves. Firewood is stacked. And when the trees are bare and the insects have disappeared with the thin warmth of the sun, autumn is about to give way to winter.

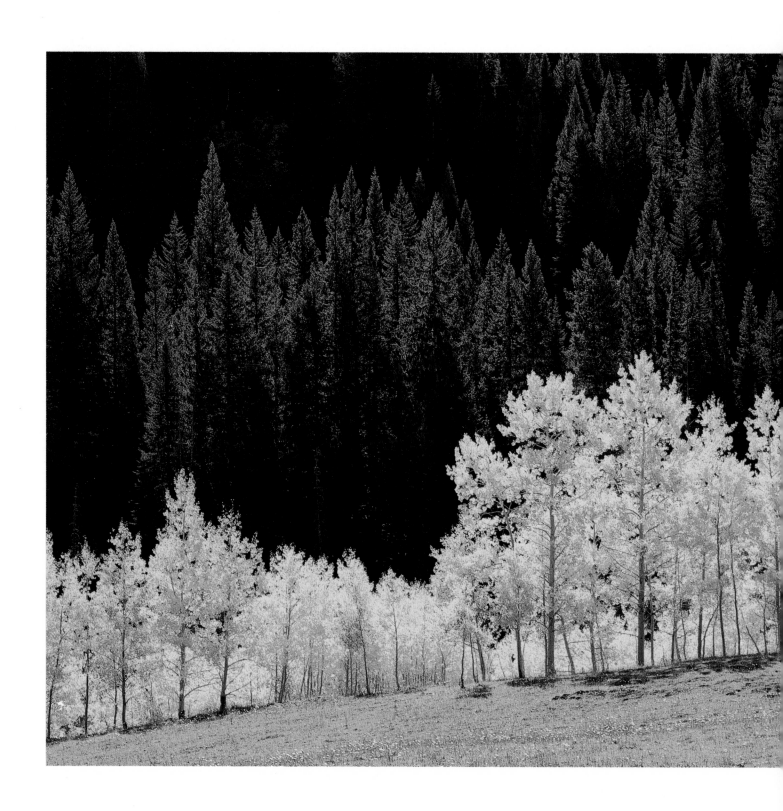

ABOVE Etched across the dark timber in brilliant yellow, this
filigree of aspen is characteristic of the autumnal hues painting
the landscape. This stand of aspen on Maroon Creek catches the
sun and is electrified.

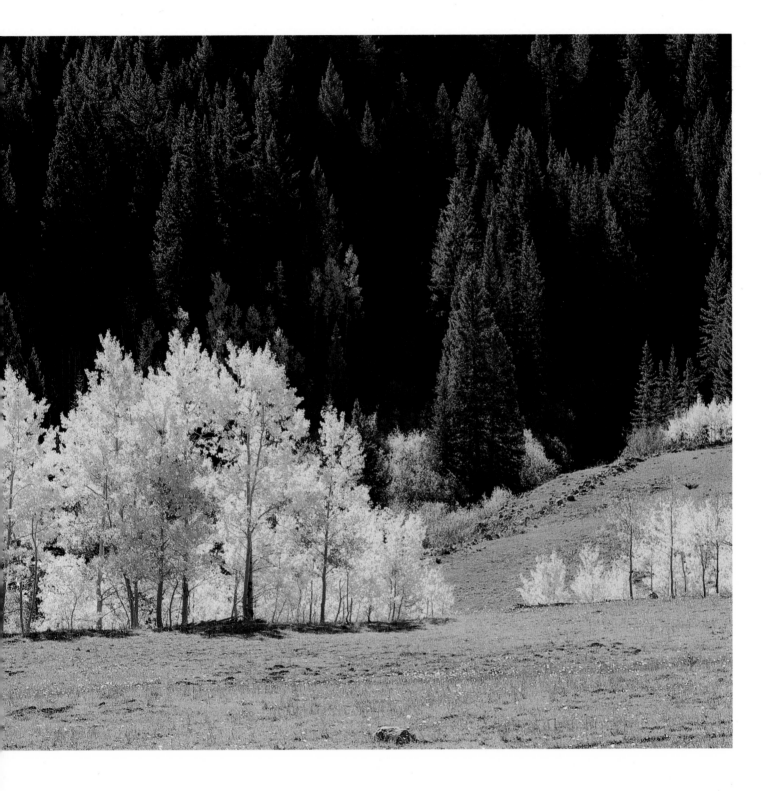

OVERLEAF Framed by gold, Mt. Daly rises from the Snowmass Creek Valley. Daly is easily recognized for the stripe across its face, a geologic feature resulting from a lighter layer of sedimentary rock sandwiched with the predominant darker rock and uplifted at an angle.

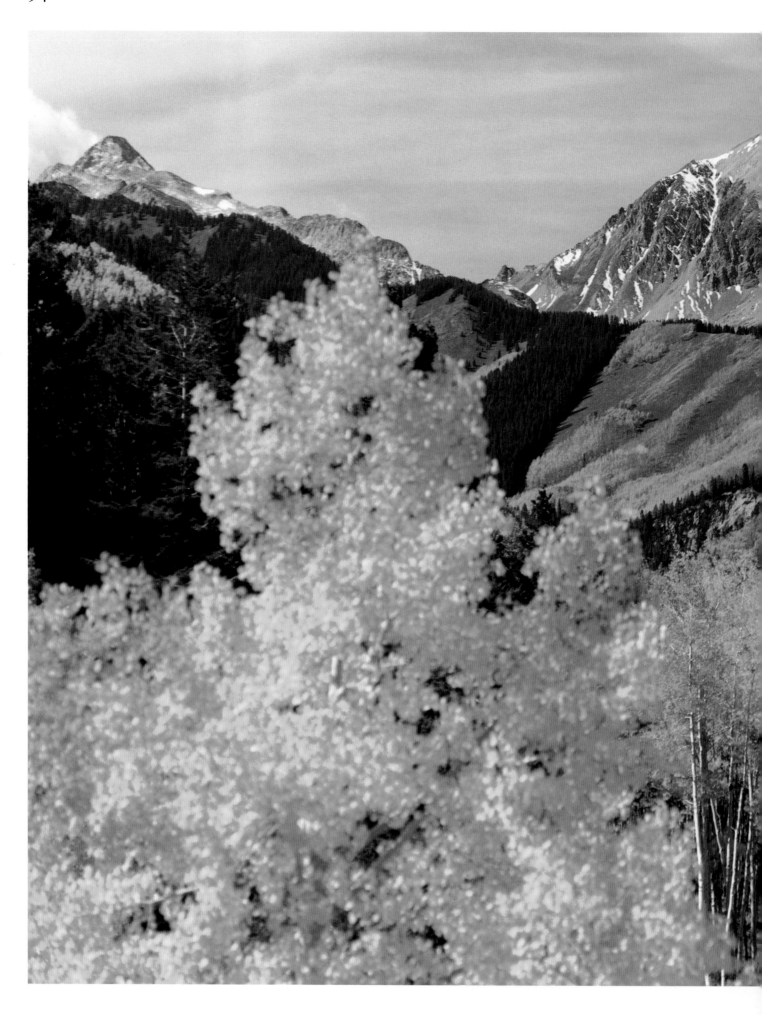

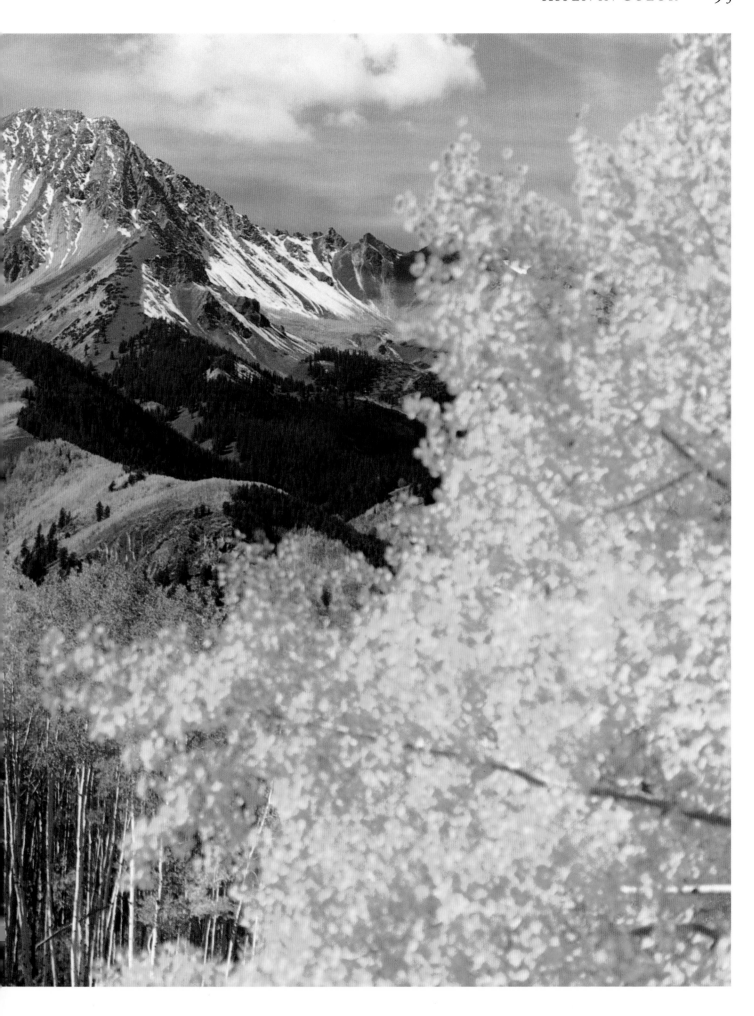

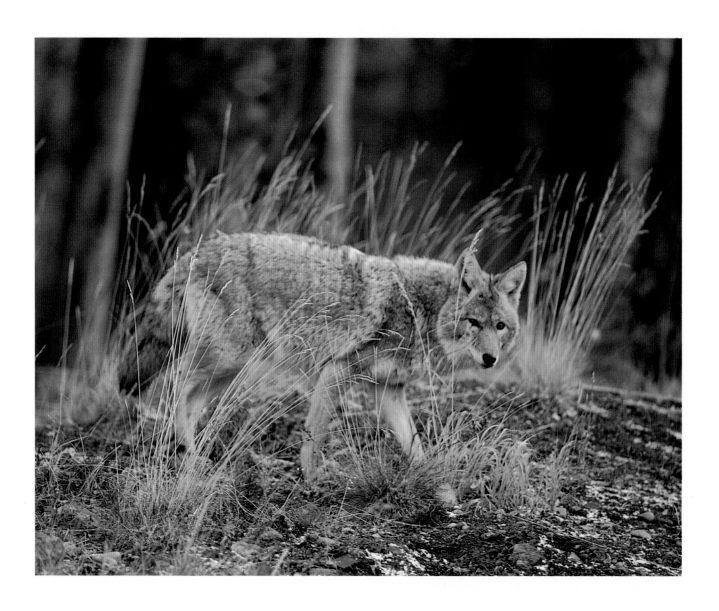

A coyote moves warily through the dry grasses of a forest clearing on Sopris Creek, eyes sharp, senses keen. Long a symbol of the West, the coyote endures as a legendary predator whose baleful call echoes the wild country.

RIGHT A white mist settles in a denuded aspen forest on a cool morning when the trees have shed their leaves and the brush is still in color. A fleeting season for its quick changes, fall marks a major transition in the mountains.

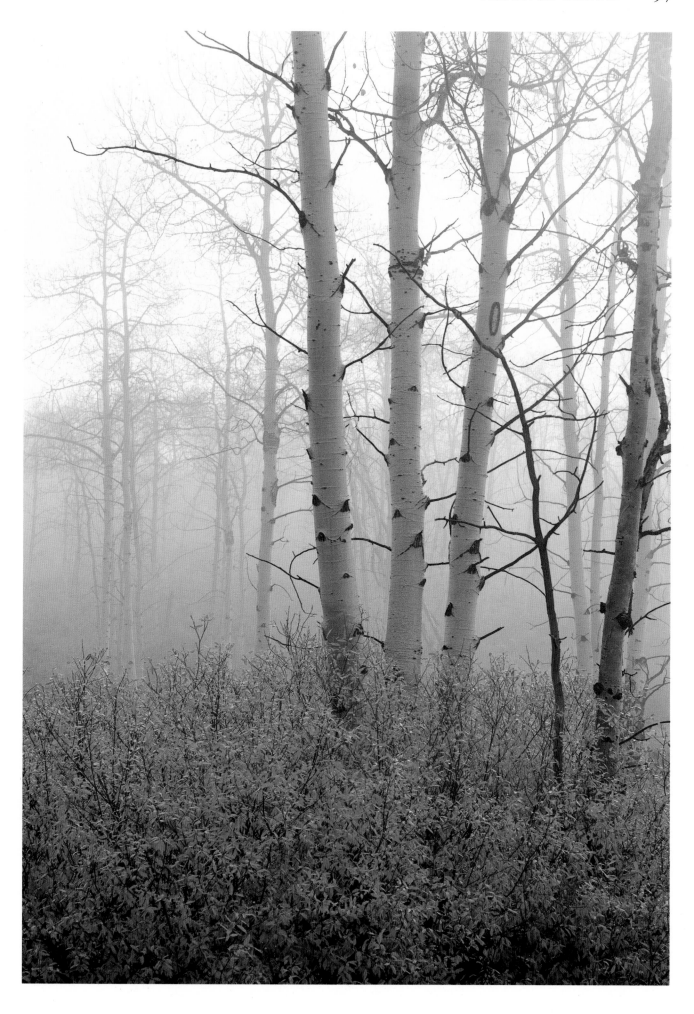

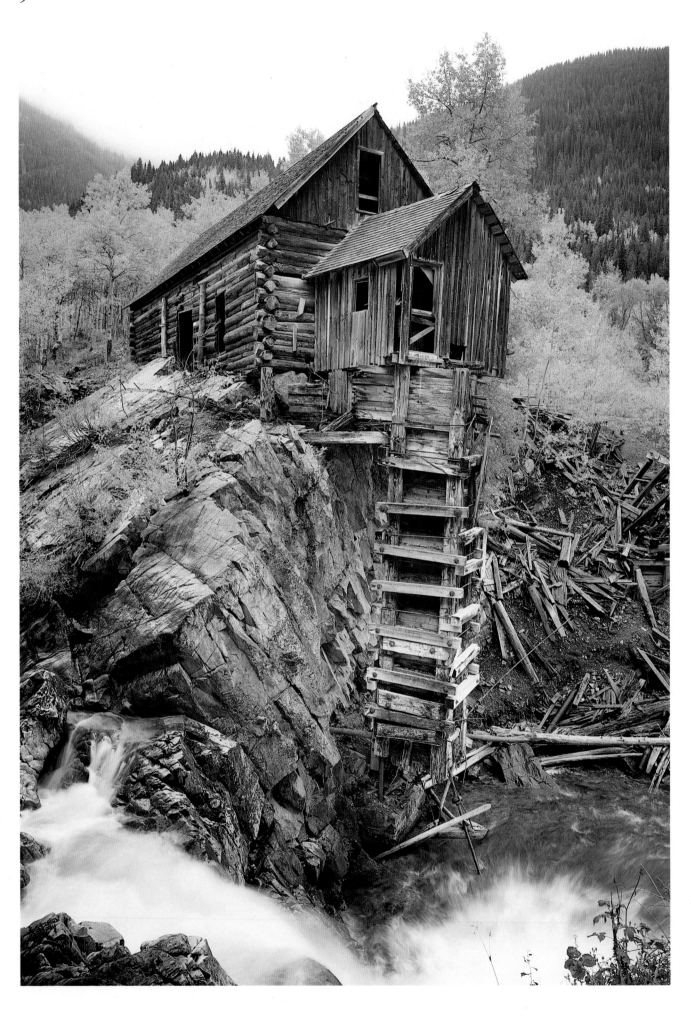

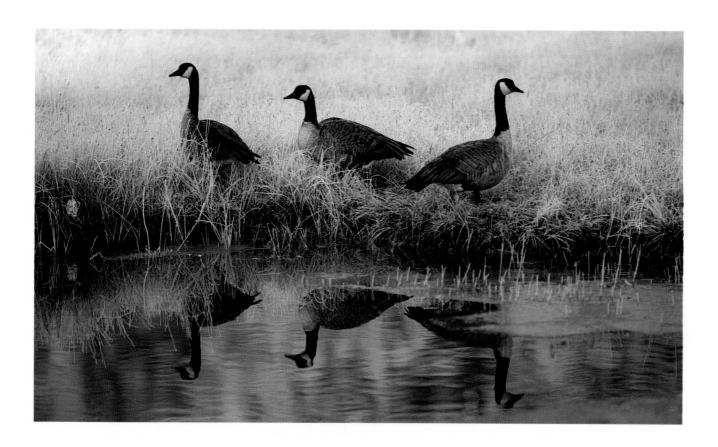

LEFT The Crystal Mill, also known as Dead Horse Mill, stands above the Crystal River, a tributary of the Roaring Fork River. Built in the 1880's, the mill helped support the population of Crystal City when it numbered up to 500 residents. Today Crystal is a collection of clapboard buildings, weathered summer-only residences.

ABOVE Canada geese visit the Roaring Fork during the fall when their migrations bring them across the Rockies en route to warmer climates in the south. They fly in echelons as far as Mexico and herald a change of season when the sound of their honking is heard far overhead.

OVERLEAF Roundup at T-Lazy-7 Ranch on Maroon Creek brings wranglers out on a sunny day with Pyramid Peak rising abruptly in the background. The horses are ridden by summer visitors and will spend the winter in lower climates during the long, snowy season when the ranch moves to snowmobiling. But on an Indian summer afternoon the cold and snow seem far off and distant.

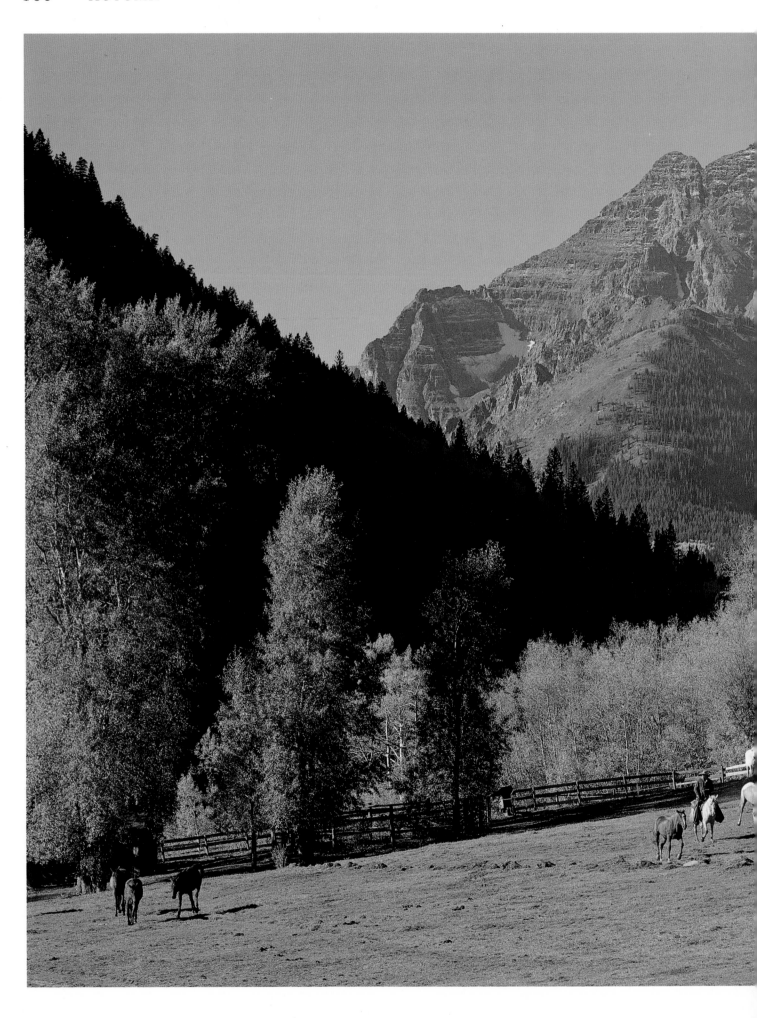

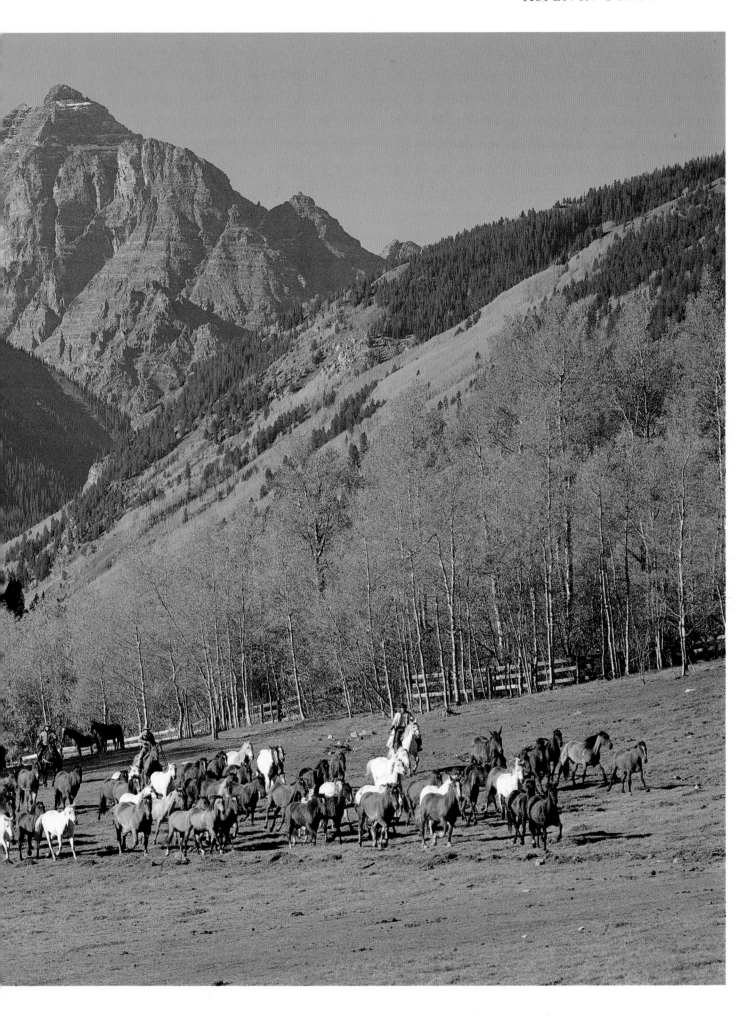

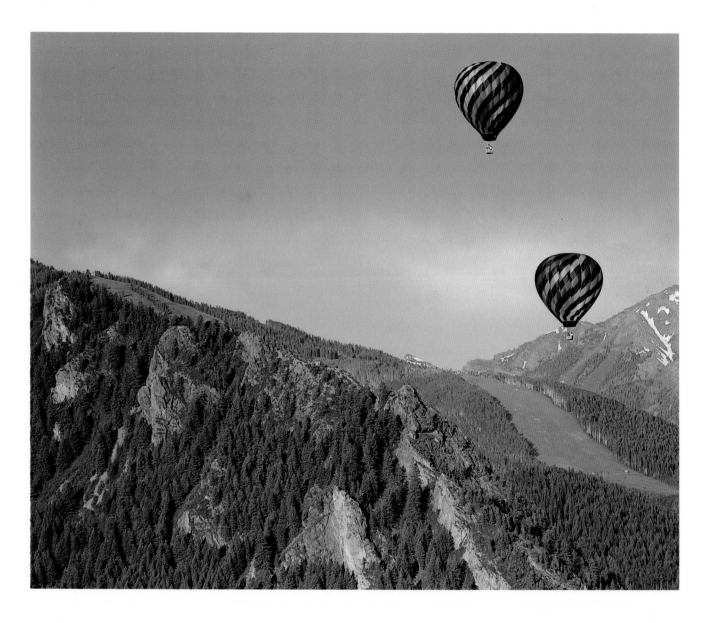

Balloons rise over Shadow Mountain, formerly called West Aspen Mountain, with the Aspen Highlands ski run, "Golden Horn," in the background.

RIGHT Autumn is the time for Ruggerfest, an Aspen tradition that draws rugby teams from around the world. Rough-and-tumble competition takes place in the center of town, at Wagner Park, where the Gentlemen of Aspen defend the town's honor and enjoy the support of enthusiastic local supporters.

OVERLEAF A flurry of color creates a pallet for nature's paintbrush as cold weather and a diminishing sun alter the chlorophyl in aspen leaves. When the wind rustles through the branches the leaves shimmer with a radiance all their own.

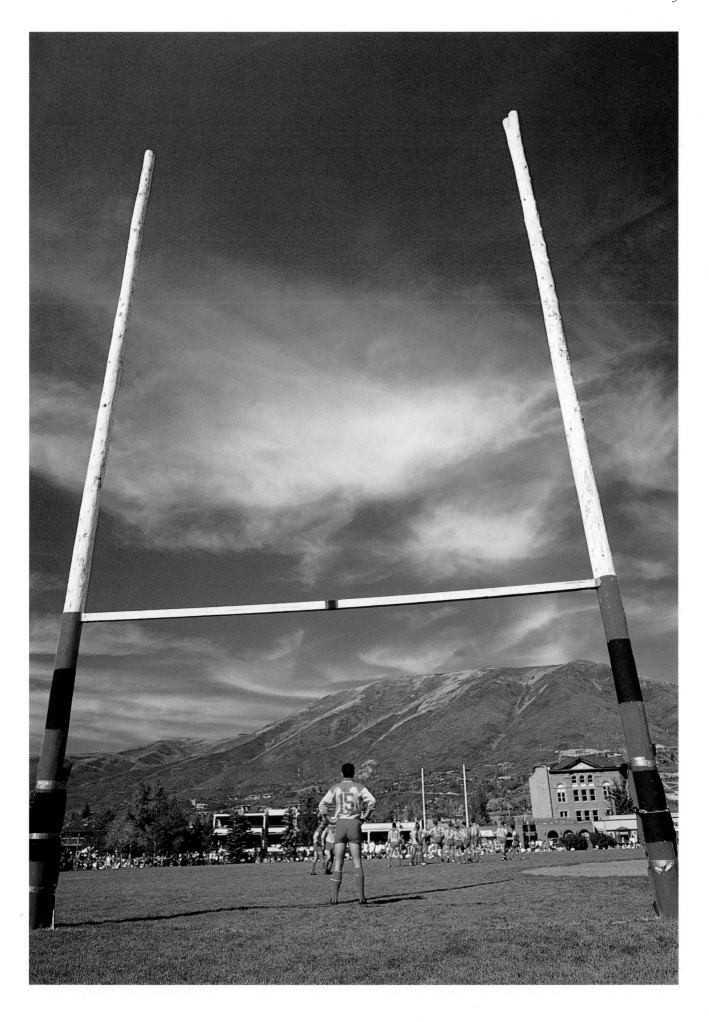

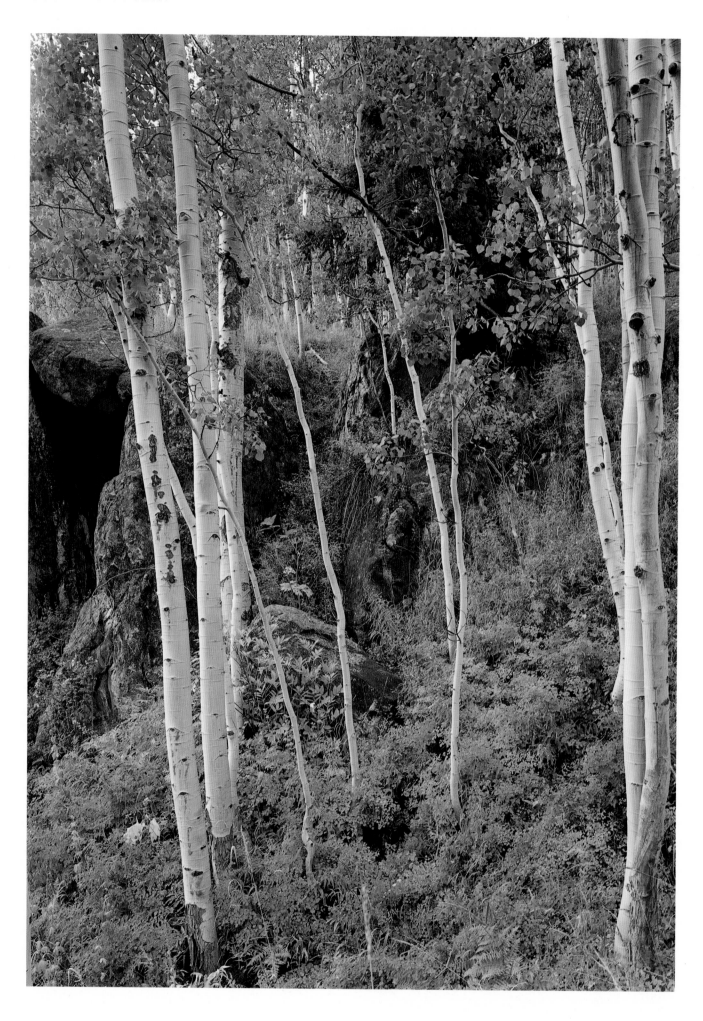

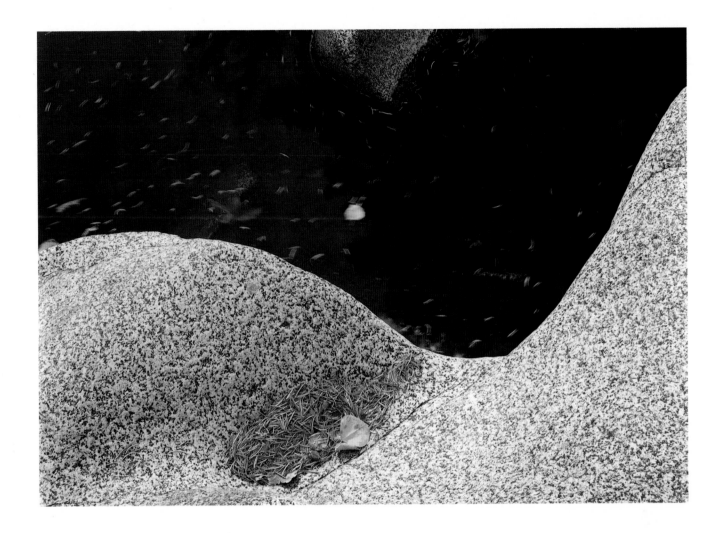

LEFT First colors show gradually among ferns and forest grasses in a protected glen off the road to Independence Pass, where young aspen reach skyward on slender trunks.

ABOVE A river sculpture where flowing water has carved the rock, where the wind has arranged pine needles and aspen leaves, makes a statement for the random design of nature.

OVERLEAF Copper Lake reflects the jagged contours of an unnamed ridge in Copper Basin. Spruce and fir rise up in silhouette against the sunlit escarpment reaching high above timber line. Copper Lake is a pleasant destination for backpackers. It is located within the Snowmass/Maroon Bells Wilderness area 20 miles from Aspen over East Maroon Pass.

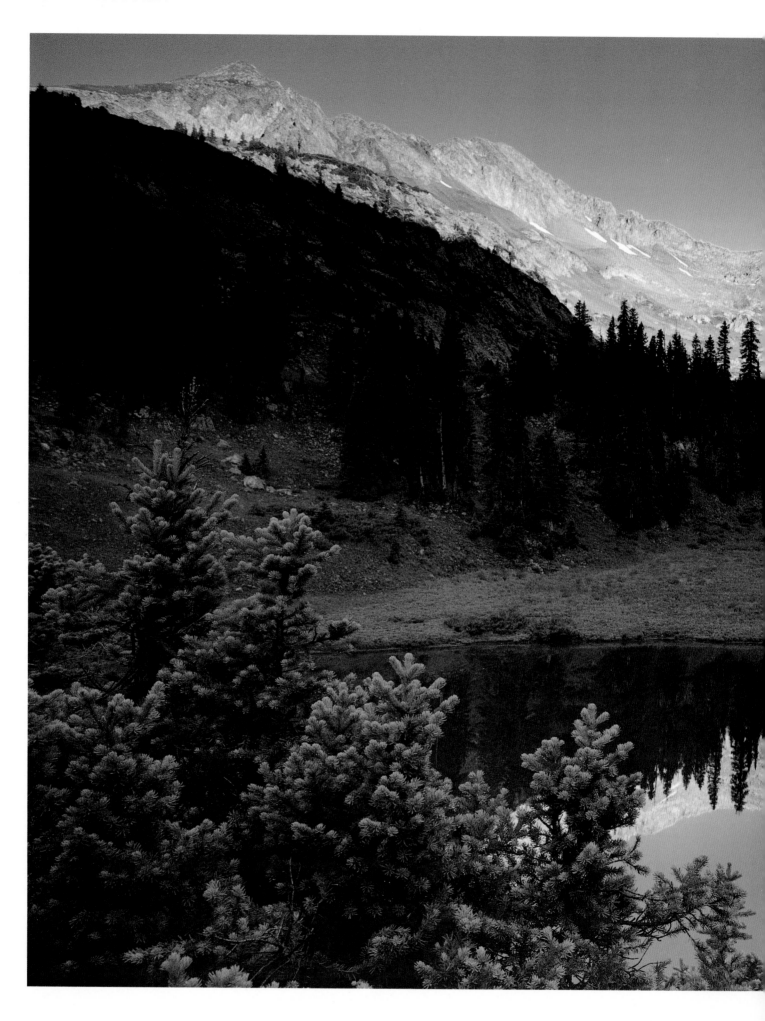

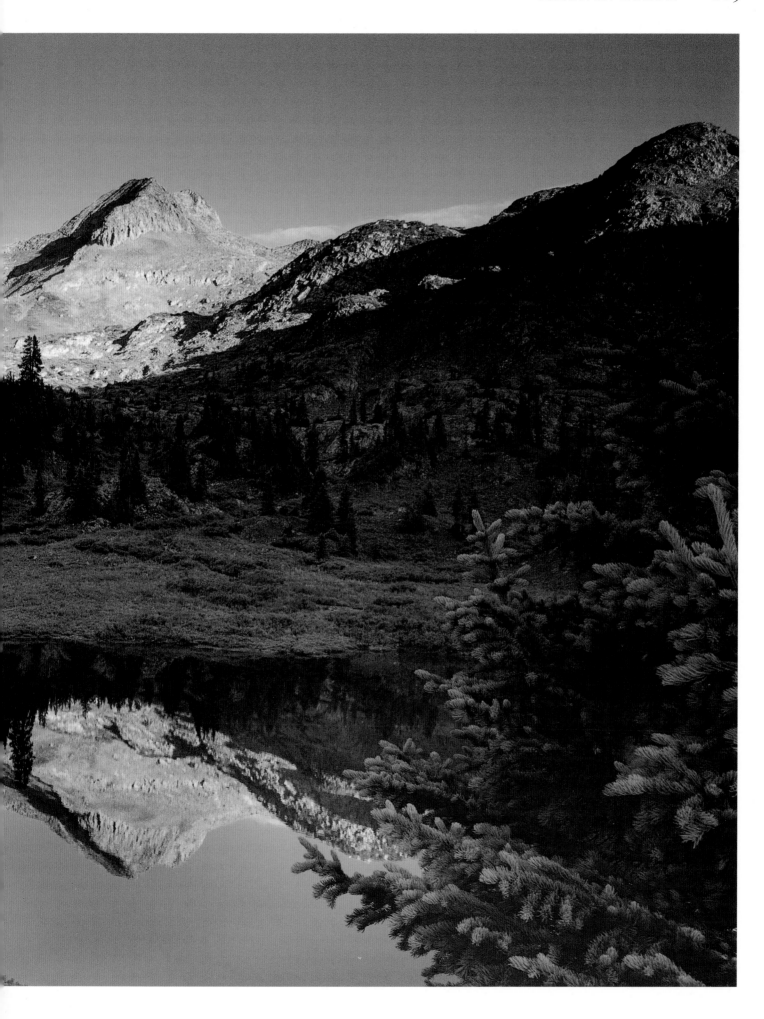

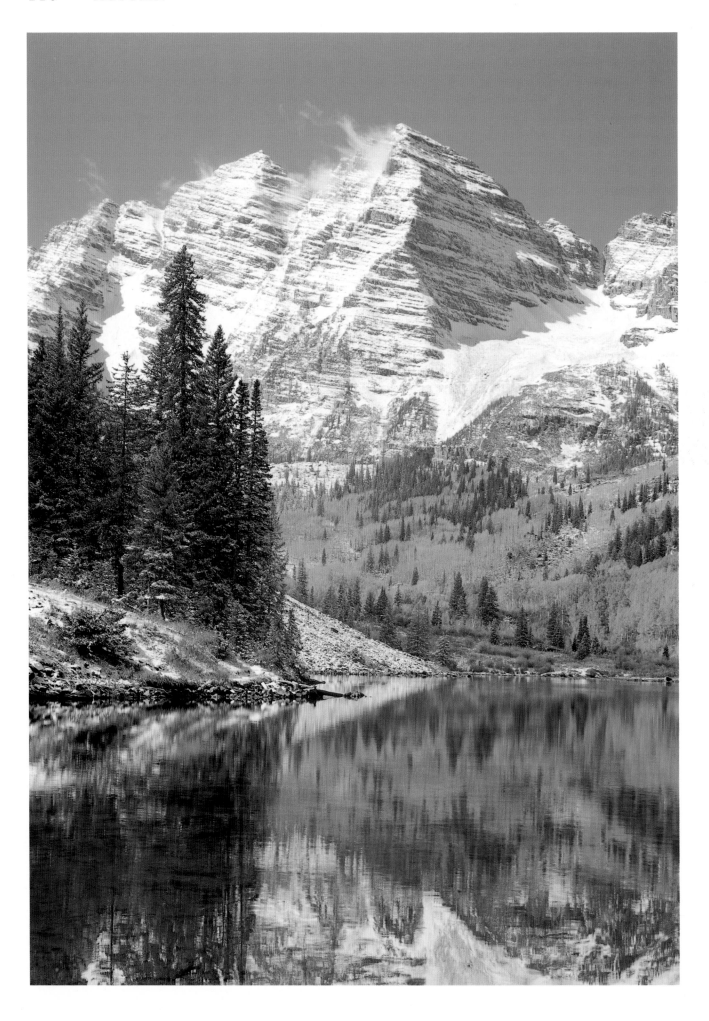

PHOTOGRAPHIC CREDITS

TITLE	PAGE	PHOTOGRAPHER		TITLE	PAGE	PHOTOGRAPHER
Grotto Falls	1	Stuart Huck		Spring on the Mall	58	Karla G. Nicholson
Ashcroft Spring, Fall & Winter	2	John Hill		Aspen Victorian	59	Karla G. Nicholson
Gondola & Fireworks	4	Patrick Collins & Judy Hill		Church Ladders	60	Karla G. Nicholson
Aspen Branch	5	Judy Hill		Pitkin County Courthouse	61	Karla G. Nicholson
Aspen Mountain	7	John Hill		Alpine Garden	62	John Hill
Fireweed	8	John Hill		Highland Bells	64	John Hill
Pyramid with Clouds	11	John Hill		Triangle Pass	66	Judy Hill
Aspen in the 1890's	12	Aspen Historical Society		Tenting at Copper Lake	68	Judy Hill
Aspen in the 1990's	14	Karla G. Nicholson		Packing into the		
Little Annie	17	Stuart Huck		High Country	70	Judy Hill
Top of the World—Winter	18	Judy Hill		Snow in the Air	71	John Hill
Aspen Aerial	20	Stuart Huck		Roaring Fork Triptych	72	John Hill
Mt. Daly Morn	22	John Hill		Rose Crown & Stream	74	Wayne Hill
Winter Snow	23	John Hill		Peaceful Valley	76	John Hill
Face of Bell	24	Tony Demin		Flowers on a Slope	77	Karla G. Nicholson
Winter Labyrinth	26	Stuart Huck		Adventures Aloft	78	Judy Hill
Maroon Creek Road	27	John Hill		Mountain Biker	80	Tony Demin
World Cup Downhill	28	Tony Demin		Windsurfing at Ruedi Reservoir	81	Judy Hill
Flags	29	Stuart Huck		Juggler	82	Gregg Adams
Gondolas	30	Tony Demin		Music Festival Tent	83	Gregg Adams
Skier	31	Tony Demin		Hyman & Galena	84	Karla G. Nicholson
Winternational	32	Stuart Huck		House & Fence	85	Tony Demin
Galena Street	34	John Hill		Popcorn Wagon & Fountain	86	John Hill
Lift 1A	35	Judy Hill		Fourth of July Parade	87	Judy Hill
Rubey Park Terminal	36	Tony Demin		Snowmass Balloon Festival	88	Karla G. Nicholson
Red Onion	37	Judy Hill		Walk into Fall	90	John Hill
Street Light Morning	38	John Hill		Aspen & Spruce	92	Stuart Huck
Christmas at Sardy House	39	Gregg Adams		Mount Daly in Fall	94	John Hill
Cozy Point	40	Judy Hill		Coyote	96	Dale Paas
Glendale Stock Farm	42	Judy Hill		Aspen in the Mist	97	Judy Hill
Hallam Lake	44	Ken Hutchison		Crystal Mill	98	Ken Hutchison
Pasque in the Snow	46	Stuart Huck		Three Geese	99	Dale Paas
Summer Moon Lake	47	Stuart Huck		Roundup	100	John Hill
Skiing Mountain Boy Gulch	48	Tony Demin		Balloons over Shadow Mt.	102	John Hill
Fishing on the Frying Pan	49	Tony Demin		Ruggerfest	103	Tony Demin
Crater Lake Trail	50	Judy Hill		Aspen Branch	104	Judy Hill
Morning Cascade	52	Ken Hutchison		First Colors	106	John Hill
Pink Pasque	53	Stuart Huck		Fallen Leaf & Rock	107	Stuart Huck
Glacier Lilies	54	Karla G. Nicholson		Copper Lake	108	Judy Hill
Bighorn Lamb	55	Dale Paas		Maroon Reflection	110	Ken Hutchison
Blue Independence	56	Ken Hutchison		Moonrise over the Pass	112	John Hill

Original photographic prints of the illustrations in this book are available from the photographers through Hill Photography. For details and prices, write to:

HILL PHOTOGRAPHY

Post Office Box 4198 • Aspen, Colorado 81612

LEFT *Maroon Lake and the Maroon Bells show the blend of seasons. Snow on the peaks and golden hues on the aspen trees usher in winter.*

OVERLEAF *Soft clouds catch the setting sun's pink hues as moonrise comes over Independence Pass at 12,095 feet.*

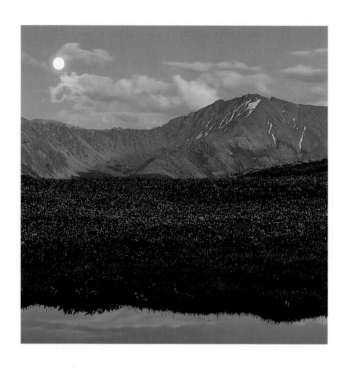